Fantasy Fashion
art studio

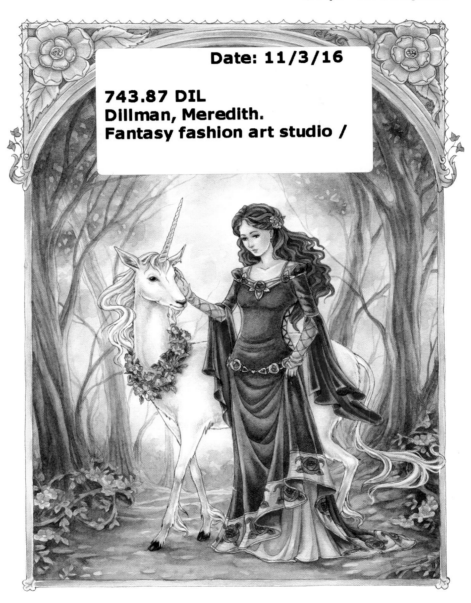

Meredith Dillman

IMPACT
CINCINNATI, OHIO
impact-books.com

Contents

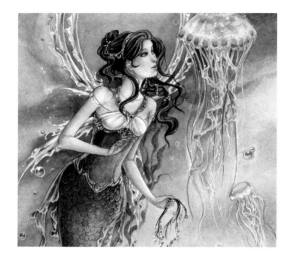

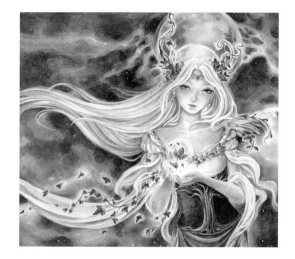

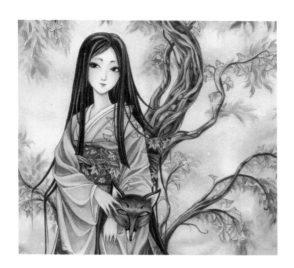

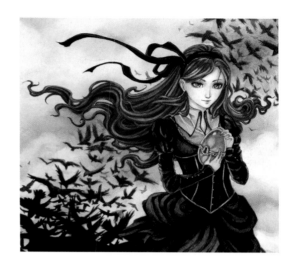

Introduction

I HAVE BEEN FASCINATED by fashion and historical costumes for a long time. When I was introduced to the world of Pre-Raphaelite paintings as a teen, I longed to be able to recreate the romantic medieval dresses to one day wear. Although sewing is not my forte, I have enjoyed painting fantastic creations that I couldn't otherwise bring to life.

As my artwork changed from anime-inspired to fantasy and fairies, I also found inspiration in the natural world. Visiting Japan made me appreciate the simple, yet elegant designs and patterns on kimonos and woodblock prints. At times my favorite styles have all come together to form a beautiful new style such as the late eighteenth century Aesthetic, Art Nouveau, and Arts and Crafts movements. These combined the twisting vines found in nature with myths and legends and aspects of Asian art.

The best part of fantasy art is being able to draw whatever you imagine. You are free to start with a historical inspiration and make it as fantastical as you desire or combine multiple themes to create something new. If you imagine a character as a forest fairy in ancient China—you can make it happen!

Each section of this book contains a painting demonstration on a different theme or historical period. Use the information in each section as a jumping-off point to inspire your own illustrations. Once you know the basics, you can use this information to research historical examples of any style in further detail.

The paints I use throughout the book are mainly made by M. Graham. I prefer to use them because of the high pigment content and honey binder. I find they are brighter than other watercolors I've used and they don't dry out completely when I squeeze them onto my palette. I also use Winsor & Newton paints when I need a greater variety of colors.

MATERIALS

¼" 6mm flat brush

nos. 0, 1, 2, 4, 8 round sable or synthetic sable brushes

hot-pressed watercolor paper

pencil

waterproof ink

PAINTS

Alizarin Crimson	Permanent Alizarin
Brown Madder	Crimson
Burnt Sienna	Phthalo Blue
Burnt Umber	Quinacridone Red
Cadmium Orange	Quinacridone Violet
Cadmium Red	Raw Sienna
Cadmium Yellow	Raw Umber
Cerulean Blue	Sap Green
Cobalt Blue	Sepia
Cobalt Violet	Ultramarine Violet
Cobalt Violet Deep	Ultramarine Violet Deep
Dioxazine Purple	Viridian
Hooker's Green	White Gouache
Lamp Black	Yellow Ochre
Payne's Gray	

PAINT MIXES

If I describe a paint mix as "a mix of X and Y," it is close to equal proportions of each color, while if I write, "bit or a little of Y" it means less of the second color. "A touch of" a color means very, very little. "Light" means the paint is diluted with a little more water, and "pale" or "very light" means add even more water to the paint. Watercolor mixing is inexact because water isn't measured, so use your best judgement when mixing colors to come up with something close to what you see in the pictures.

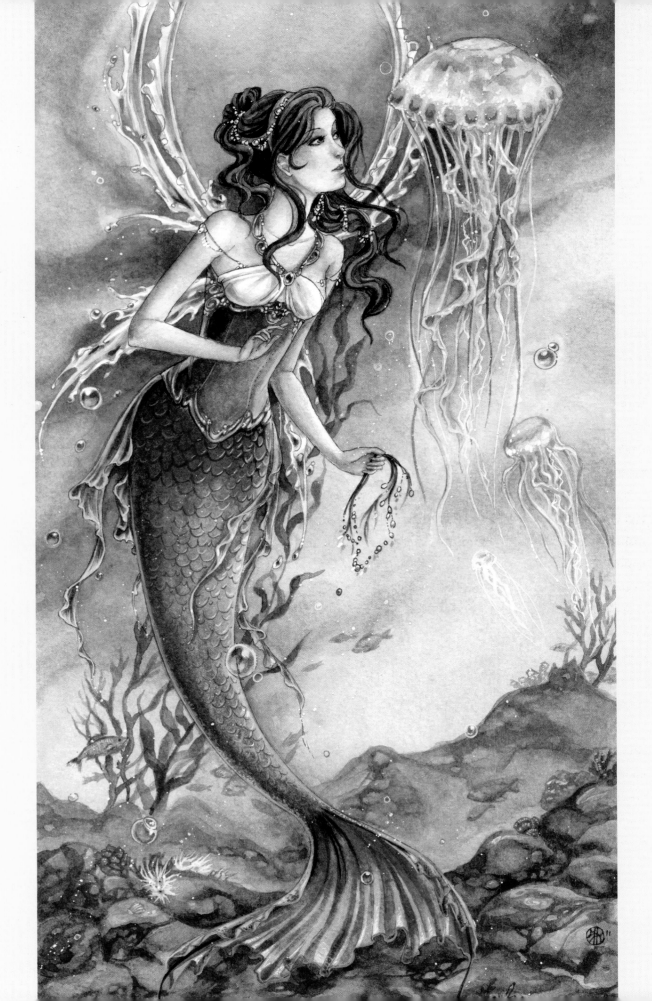

PART ONE

Basic Drawing and Painting Techniques

*E*VERY PAINTING STARTS with an idea, but sometimes you don't know how to transform that idea into a finished painting. Getting to know a variety of art tools will help bring your imagination to life and find the medium that works best for you. While this book concentrates on using watercolors, many of the design and color principles can be applied to acrylic or digital art. By learning the basics of any painting medium first, you can avoid frustrating mistakes.

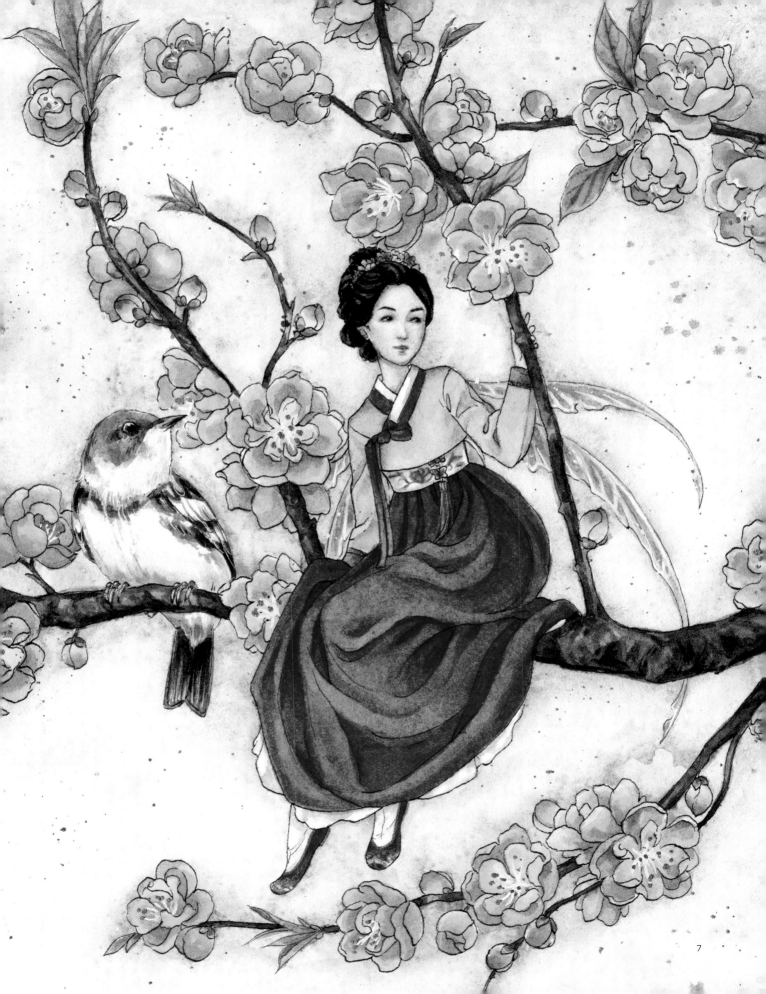

Drawing Tools

WHILE MOST OF THE DEMONSTRATIONS in this book will focus on painting with watercolors, equally important are pencils, pens and inks.

Pencils and drawing tools are invaluable for getting your ideas on paper. No matter what kind of finished painting you have in mind, you will probably start with a pencil.

PENCILS

You are probably familiar with traditional wood pencils and have drawn with them before. There are also a variety of pencils that are better for some more artistic uses. Mechanical pencils are a good choice since they don't require sharpening and come in many sizes. If you like to draw very small details, you can choose a smaller size like .3mm or .5mm, or you can use .7mm lead to draw bold lines. For even thicker lead, use a leadholder, which is similar to a mechanical pencil but allows for thicker lead you can shave to a point.

LEADS

Choose your pencil lead based on hardness. All leads are rated on a scale from 8B to 8H. B means soft and H means hard. Pick a few near the middle of the scale, like HB or 2H, for most sketching. If a lead is too soft, it's easy to smear. If it's too hard, it becomes difficult to erase.

COLOR PENCILS

Experiment with color pencils for outlining drawings or sketching. Choose a brown or sepia to give your drawing an antique appearance. A lighter brown can also look less harsh than a dark pencil. Try using non-photo blue pencils for sketching lightly or creating guidelines that you will draw darker lines over. However, non-photo blue pencils are not a good choice for a drawing you intend to paint over because they don't erase well.

ERASERS

White vinyl erasers are great because they create less dust and fewer smudges. Use a large one for cleaning up pencil lines after inking. Often mechanical pencils don't include erasers or they are used up fast, so an additional mechanical eraser is very helpful for erasing small details. If you intend to create a finished pencil drawing, use a kneaded eraser, which can be reshaped or pointed to erase smaller areas.

TRANSFER A DRAWING

You may wish to draw directly onto the watercolor paper you'll later paint on, but this doesn't always work out. If you make a mistake or sketch on paper that won't hold up to paint, there are a number of ways to transfer your drawing to suitable paper for painting:

- Use a portable lightbox to trace your sketch. In a pinch you can put a lamp under a glass table or tape your drawing to a window where the sun is shining (although this makes it a little hard to draw).
- Place a sheet of carbon paper or graphite paper between your drawing and watercolor paper. Tracing your drawing will transfer lines to the paper below. You can also coat the back of your sketch with graphite and use the same technique.
- Have a copy shop photocopy your sketch onto watercolor paper.

Inking Tools

INK CAN PLAY AN IMPORTANT PART even when working with watercolor and is good to be familiar with because detailed comic and fantasy art illustration styles often place importance on strong linear outlines.

CHOOSING A PEN

There are many types of pens available, and each is made in a range of sizes and styles. Some pens will work better for you than others, depending on your purpose. Felt-tip pens made for scrapbooking and comics are popular and usually waterproof. They work best for drawing lines of uniform thickness and come in a range of colors.

If you like the feel of drawing with a brush, brush-tipped pens are available with either felt tips or hair tips and have the advantage of the greatest range of line width with one pen. Nib pens are another option, commonly used by comics professionals. Similar to calligraphy pens, they draw lines of varying width depending on the direction and amount of pressure you place on them. You can use one nib holder for a variety of different nibs.

CHOOSING INKS

The most important consideration if you plan to paint over your drawing is to make sure the ink in your pen is waterproof. If it's not labeled, be sure to check by testing it on scrap paper to make sure it doesn't bleed and muddy your paint. For nib pens, acrylic inks (which come in traditional ink bottles) are a great option for truly waterproof ink. Since acrylic inks also come in many colors, try inking different parts of your drawing according to the colors you plan to paint.

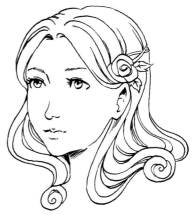

Nib Pen
A nib allows you to draw both thick and thin lines and change the nib to a different type.

Felt-Tip Pen
A felt tip creates uniform lines. Any thickness must be made by going over the line several times.

Paintbrush
A small paintbrush with ink creates thicker lines, but has the flexibility to draw thin lines or vary the width expressively.

Nib Pens

NIB PENS WORK DIFFERENTLY than other pens and take some practice. Similar to a calligraphy pen, the ink comes separately, and the nib pen has the ability to draw both thick and thin lines with one tip.

Remember to always draw the pen toward you instead of pushing it. Pushing the pen the wrong way will make jagged lines and damage the nib. Instead, move your paper around to make drawing certain lines more comfortable.

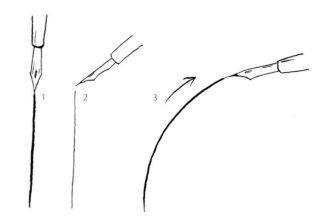

Drawing Lines
1. Holding the nib with the widest part facing up creates a thicker line.
2. Turn the nib to the side for a thinner line.
3. Drawing an arc following your drawing hand will be easier than pushing against the tip.

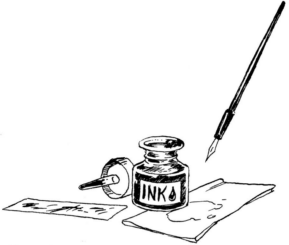

Inking Tools
Use one small pen holder and a selection of nibs. Nibs numbered 100 through 108 are common for drawing comics and illustrations. For drawings I plan to paint, my favored nib is a 107. A bottle of waterproof ink, scratch paper and a wet paper towel for cleaning the nib are also helpful.

Shading Techniques
Use crosshatching to create darker areas. Stippling—small dots—can be used for shading or to create fabric pattern and lace details.

Varying Lines
The beauty of using a nib pen is the ability to vary the line width with one nib. Practice alternately putting pressure on the nib and releasing it as you draw it across the paper. Try changing the angle of the pen while drawing.

Ink a Sketch

INKING OVER YOUR SKETCH IS a useful technique for a number of reasons. You may want to make some of your lines more prominent or refine your drawing so you can erase the pencils underneath. This provides a nice base for painting watercolors over, while allowing the drawing to stand out.

Tips to Remember

- Draw with the pen at an angle, not straight up.
- Don't dip the nib too far; keep the holder clean and avoid drips.
- Clean the nib often with a wet paper towel.
- Move the paper around instead of drawing at uncomfortable angles.
- If your drawing will be painted over, leave pencil lines where you would rather paint lighter lines or details, such as a background landscape.

1 Ink the Outline
Ink the outermost lines in your sketch as well as objects in the foreground that overlap other lines. The outlines of larger forms can be thicker than inner details. Work from top to bottom to avoid smearing ink with your hand.

2 Ink Inner Forms
Ink the outline of her face, the main drapery lines, inside the flowers and shadows between sections of hair and the edge of her belt.

3 Ink Details
Add smaller details like facial features, designs on her belt and decorations on the dress. Add depth to the hair and drapery by drawing lines that follow the direction of the drapery and main lines in the hair. Ink the outline of the background flowers last with a thinner line. Since they are in the background, keep them simple.

Gathering Inspirations

ALL PAINTINGS START with inspiration. Sometimes it happens unexpectedly, but if you know where to look, an idea might be waiting for you.

Resources

Reference Books and Websites

Costume history books are a great resource. Collections of Victorian fashion plates are available in books. You can find many of these books in your local library.

Costume websites are helpful for finding detailed information about particular eras. Many of them are geared toward sewing and reconstructing. Many museums also have historical costume collections you can look at online.

Here are a few good resources:

- costumepage.org
- fashion-era.com
- costumes.org
- metmuseum.org/collections

Keep a Sketchbook

Carrying a pocket-sized sketchbook is a great way to record ideas or sketch scenes that inspire you.

Copyrights

When using other people's photos for reference, make sure to respect copyrights. Stick to using photos for learning purposes unless you have permission from the original photographer or artist. Using photos for inspiration and reference to learn how a particular tree looks, or how a leopard's spots look, or what colors to use for a sunset is fine.

Use Photographs for Reference

The greatest tool for finding inspiration and drawing reference is taking your own photos. By carrying a digital camera, you can snap photos of interesting scenes, plants and architectural details wherever you go. If you have a particular subject in mind, take a trip to photograph the references you want. For example, the zoo or a walk in the woods might yield great results!

If possible, ask friends to pose for paintings or help you take photos of yourself. If you are having trouble drawing an odd hand position, take a quick snapshot to draw from.

Collecting Reference Materials

Sometimes you don't have a camera, and the real thing is better than a photo. Having the object you want to draw allows you to turn it over and examine it from all angles. Collect fallen leaves, flowers, mushrooms or seashells to find inspiration in the natural world.

You might want to draw collected flowers right away or leave them to dry. Always make sure you have permission to pick flowers wherever you go to avoid picking any endangered species.

Watercolor Painting Tools

YOU NEED A VARIETY OF TOOLS for painting watercolors, each of which comes in a range of options. Find the tools that work best for you and allow you to create with ease.

PAINTS

When picking watercolor paints, first decide whether you would like pans or tubes.

Pans are dry and must be rewetted with each use. They are easily portable and sold in small sets for travel. Tube colors are moist, and you can squeeze out as much or as little as you need to use.

Watercolor paints are commonly sold in artist-grade or student-grade with a wide range of prices. Artist-grade watercolors have a higher concentration of pigment and use less binders and fillers, making them brighter and longer lasting. Student paints often use cheaper or synthetic pigments to achieve the same color. Student-grade watercolors are fine for learning, but if you can afford artist-grade paints, you will see the difference they make.

Most important, look at the lightfast rating on the label. Paints are labeled with a rating of I, II or III, with I being the best. This refers to how fast the paint will fade under direct sunlight. Certain pigments such as Alizarin Crimson fade easily, so avoid pigments with the lowest rating or choose a permanent substitute (just look for *permanent* in the name).

BRUSHES

Watercolor paintbrushes come in many shapes such as round, flat, chiseled, long and thin. Most of the time, you will use a round brush in a few sizes. Large flat or fluffy mop brushes are often used for background washes and painting large areas. Chisels, fans and long, thin rigger brushes can be used for painting foliage or thin branches.

When shopping for a round brush, look for one that keeps its point when wet and has bristles that spring back from a bent position.

Brushes are made of natural animal hair, synthetic fibers or a blend of animal and synthetic. In general, natural sable-haired brushes hold more water and last longer if taken care of, but can be expensive. If you are a beginner, synthetic or mixed brushes in a variety of sizes work just fine. Choose mostly round brushes and a flat or two for large areas.

Keep old brushes for tasks that are hard on them, like masking or dry bush techniques. Rubber-tipped brushes are a great option for using masking fluid since they are easily cleaned and keep their point.

PALETTES

Watercolor palettes are made of white plastic or china. Some palettes are made with large wells for mixing, while others have tiny compartments for a variety of colors. If you are using tube paints, you can squeeze them into the compartments and re-wet them later. Fold-up watercolor palettes are handy if you plan on traveling with your paints or just want to keep out dust when they are stored. If you are using cake paints or want to mix a large amount of color, old dinner plates work well.

PAPER

Watercolor paper is made in two basic types, smooth hot-pressed or cold-pressed, which has more texture. Roughness of paper can vary by manufacturer. Cold-pressed paper is best for larger or less detailed works. Smooth paper is easier to work with for small illustrations and detailed fantasy art, especially for inking fine lines.

Papers are sold in large sheets, notepads or blocks. Some require stretching before painting to avoid wrinkles from forming when the paper is wet. Stretching involves wetting the paper and then stapling or taping it down to a thicker board. The thicker the paper, the less likely it will wrinkle or warp. Extra-thick illustration board and watercolor blocks, which are glued around the edges, are both good choices.

EXTRA TOOLS

Besides the basics, a variety of additional tools are useful. Always have both a cup to hold water as well as paper towels or cloths for cleanup. They're also good for blotting extra water off your brushes or painting. Special, easily removed artist tape is good for securing paper to a stiff drawing board. Finally, you may want to have salt or rubbing alcohol and masking fluid handy for painting textures.

How Colors Work

A COLOR WHEEL is helpful for seeing the relationships between colors and in choosing colors to mix. The large dots show the primaries, and the smaller dots show the secondary colors.

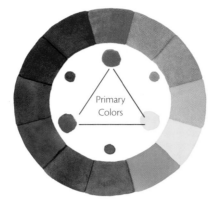

Color Wheel
This basic color wheel shows the three primary colors of red, yellow and blue, which can be used to mix the secondary colors (violet, orange, green). The tertiary colors (red-violet, blue-violet, blue-green, yellow-green, yellow-orange and red-orange) are made by mixing primaries and secondaries.

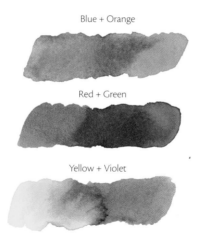

Blue + Orange

Red + Green

Yellow + Violet

Complementary Colors
These are the colors across from each other on the color wheel. Each primary color has a complement mixed from the other two primaries. Red's complement is green, a mix of yellow and blue.

For a dynamic painting, choose a color scheme made of complementary colors to create contrast. Mixing complements makes a color darker and is useful for painting shadows.

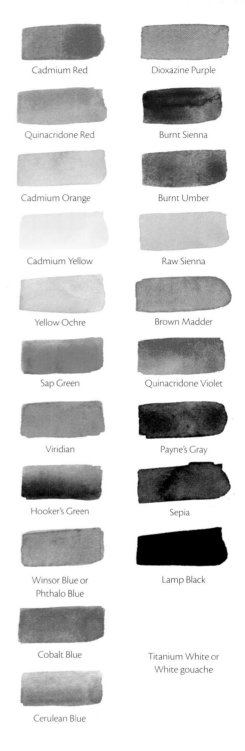

Cadmium Red

Dioxazine Purple

Quinacridone Red

Burnt Sienna

Cadmium Orange

Burnt Umber

Cadmium Yellow

Raw Sienna

Yellow Ochre

Brown Madder

Sap Green

Quinacridone Violet

Viridian

Payne's Gray

Hooker's Green

Sepia

Winsor Blue or Phthalo Blue

Lamp Black

Cobalt Blue

Titanium White or White gouache

Cerulean Blue

Color Palette
Start your color palette with the primary and secondary colors or use a set that includes many basics. You may wish to expand your palette to include more pigments later. Watercolors are available in warm and cool versions as well as many unusual or bright colors that are hard to mix.

Mixing Color Schemes

THE OVERALL COLOR SCHEME you choose can determine whether the mood of your painting appears dynamic, loud, quiet or peaceful. Different combinations create more contrast than others.

Primary
The most basic color scheme, which uses blue, red and yellow, creates both contrast and harmony. A primary scheme was used in many Renaissance paintings and can lend a traditional look to your art.

Analogous
Use colors near each other on the color wheel or by choosing a range of colors between two primaries to create an analogous color scheme. These colors make pleasing compositions because they are related. Use the series of colors between yellow and blue for a forest scene, or red and blue for a rich night scene.

Triad or Tertiary
A triadic color scheme uses three colors spaced evenly around the color wheel. Choose one or two dominant colors and one as an accent to avoid oversaturation.

Split Complementary
Choose two colors on either side of the complement for your main colors. This color scheme is very similar to using complementary colors.

PAINTING SKIN TONES
Painting skin tones can be intimidating because no single color captures it. Paint skin with glazes of several colors: a light base, medium tone, shadow color and color for blush. Thin areas, like fingers, toes, ears and noses, and areas where the bone is closer to the skin, like joints, chin and cheeks, should be a rosier color. Some artists like to paint the shadows first, and others start with the lightest color. Experiment with similar color mixes until you find what works best for you.

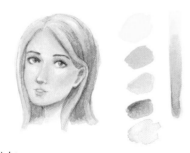

Light
Begin with a layer of shadows in Dioxazine Purple. Glaze Cadmium Yellow mixed with a little Quinacridone Red over this. Use Raw Sienna for medium tones, and for shadows use Burnt Sienna or Brown Madder. Use Quinacridone Red for blush.

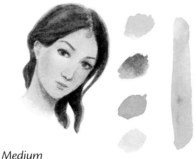

Medium
Start with a base tone of Raw Sienna. Glaze Burnt Sienna over it for the medium tones. Use Brown Madder and Quinacridone Violet for the shadows and Brown Madder for blush.

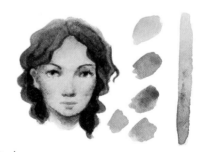

Dark
Similar to the medium tone, but start with less water and use Raw Umber and Cobalt Blue for the shadows.

13 Watercolor Techniques

ONE OF THE JOYS OF WATERCOLOR is the variety of painting techniques and effects possible. You will use some of these techniques often, while others are better for rare, special treatments.

1. Graded Wash
Mix two pools of a color: one strong and one with twice as much water. Load the first color on your brush and make even strokes across the paper. Then switch to the lighter mix and continue to the bottom. The color gradually becomes lighter.

Use this technique for backgrounds and skies.

2. Variegated Wash
This technique uses two colors. Begin painting even strokes of one color from the top. Halfway down, switch to a second color. The colors will mix in the center. They may run and make interesting patterns.

3. Wet-In-Wet
Wet your paper and apply paint with your brush. The colors spread out and create soft edges. Try this over a still-wet layer to allow the colors to flow and mix.

Use where you want a soft edge.

4. Wet-on-Dry
Allow previous layers to dry before applying more. When you paint on dry paper, your edges will be crisp and clear.

Use this to avoid muddy colors or mixing at edges.

5. Drybrush
Remove extra water from your brush with a paper towel and add paint. Or add the paint before blotting the water off. Varying degrees of texture are created by the brush hairs and paper texture, depending on how wet the brush is.

Add texture to bark, stone and backgrounds, or add shadows to areas where you want to avoid lifting previous layers.

6. Lifting out From a Wet Surface
While your surface is still wet, remove paint by dabbing it with a brush, tissue or sponge. Work fast while the paint is still wet.

Use this for leafy backgrounds, stone and bark textures, and creating highlights.

7. Lifting out From a Dry Surface

With a wet brush, dab or scrub the areas you want to remove. This will result in a crisper outline than lifting while wet. Be careful not to damage the paper by scrubbing it too much. This does not work on all pigments, so test it on scrap paper first.

8. Dropping In

Create this mottled effect by dripping or dabbing various colors onto a wet layer.

Use this technique to paint forest backgrounds, stone texture, fallen leaves or rusty metal.

9. Masking

Paint the masking fluid on dry paper. Let it dry completely, then paint over it. After it's dry, rub the masking fluid off with your finger or an eraser. Masking fluid is hard to clean off brushes, so use an old or rubber-tipped one, or dip it in liquid soap first. This works best for small areas that are difficult to paint around, like snowflakes, stars and other small highlights.

Use masking fluid to mask an area you want to keep white.

10. Spattering

Hold your paint-loaded brush over the paper and lightly tap it. Try on wet or dry paper for different effects. Lay paper over the areas you wish to avoid.

Spattering is useful for distant trees and adding texture.

11. Salt

To create a sparkly effect, sprinkle salt over a very wet area of paint and allow the paint to dry completely, then gently rub the salt off. The more pigment you use, the more pronounced the effect.

Use this technique to create background texture or sparkling, magical effects.

12. Rubbing Alcohol

Sprinkle or dab rubbing alcohol over wet paint to push the paint away and create interesting bubble-like shapes.

Use this to create bubbles in water or add texture to backgrounds.

13. Water Drops

Spatter or drip water over a freshly painted, wet area. The effect is more delicate than using rubbing alcohol. Use this technique to create clouds, distant backgrounds and stone textures.

BASIC WATERCOLOR TECHNIQUES

Blending and Crisp Edges

AN ADVANTAGE OF WATERCOLOR is the ability to paint both a hard edge and a soft edge by adding water. Practicing some simple techniques allows you to better control the paints and avoid bleeding colors.

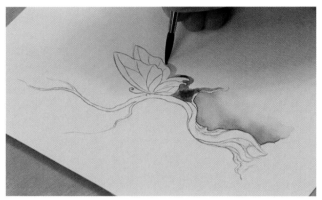

1 Start With the Tight Corner
Select a round brush that is small enough to paint around the corners but large enough to hold plenty of water. Paint along the edge of your drawing with a moderately dark color. Add more color to your brush to push the color out farther.

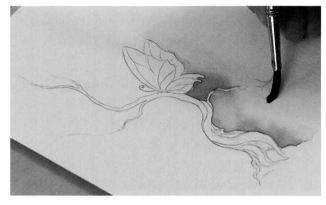

2 Blend the Color Outward
Begin diluting the color by adding water to your brush and painting along the edge. Continue painting outward quickly to keep the edge of the paint wet; otherwise, it will dry with an obvious edge.

Continue blending the color outward and into the paper by painting clear water along the edge until it disappears.

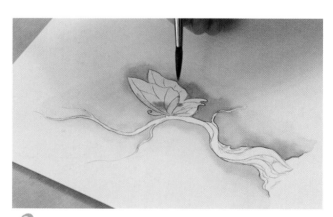

3 Paint the Butterfly
Paint a concentrated color along one edge of a foreground element, in this case the butterfly.

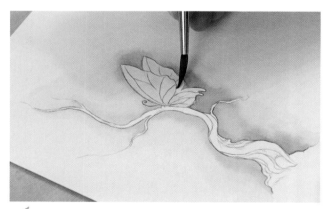

4 Create a Gradient
Quickly rinse your brush and blend the color outward with clear water.

Glazing

GLAZING IS THE PROCESS of applying a thin layer of paint over a previous layer, letting the bottom layer show through. Since watercolors are transparent by nature, it is easy to take advantage of this effect. When a transparent color is painted over another, the result is brighter and more luminous than if you mix the colors on the palette.

MATERIALS

assorted brushes

hot-pressed watercolor paper

pencil, pen and black waterproof
 ink

PAINT

Burnt Sienna

Cadmium Orange

Quinacridone Violet

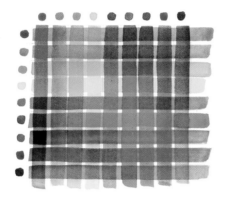

Make a Color Chart
Make a glazing chart of all your pigments for reference. Draw out a grid with the colors you normally use. Paint each color across horizontally and allow to dry. Next, paint the same colors across vertically. You'll be able to see how each color looks painted over or under the others.

1 Paint the Main Colors
Paint a light layer of Cadmium Orange over the girl's dress and the flowers in her hair. With a lighter touch, add the transparent areas to her scarf. Paint her hair with Burnt Sienna and her skin with a very pale wash of the same color.

2 Glaze the Secondary Color
Load your brush with Quinacridone Violet. Add a graduated wash to the top and waistline of her dress and the edges of the flowers. Blend with clean water until the edges are soft. Starting at the top of her head, paint a layer of the same over her hair, making it lighter toward the bottom.

3 Add Shadows
Use Quinacridone Violet to add shadows in the clothing folds, flower petals and between clumps of hair. Use a lighter mix with more water to shade her skin and rosy cheeks.

Sketching the Figure

THE HUMAN FIGURE is one of the first things drawn by a child, starting with stick figures, but it can be intimidating as we grow older. Expanding on the same basic stick figure, you can sketch many poses. Art man-nequins or posable dolls are also useful tools for figure drawing reference.

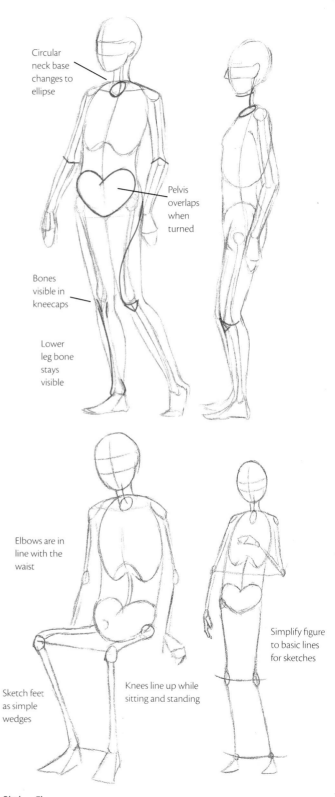

Circular neck base changes to ellipse

Pelvis overlaps when turned

Bones visible in kneecaps

Lower leg bone stays visible

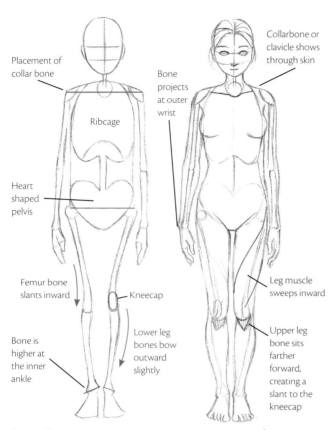

Placement of collar bone

Ribcage

Heart shaped pelvis

Femur bone slants inward

Kneecap

Bone is higher at the inner ankle

Lower leg bones bow outward slightly

Collarbone or clavicle shows through skin

Bone projects at outer wrist

Leg muscle sweeps inward

Upper leg bone sits farther forward, creating a slant to the kneecap

Front View

The skeletal structure of the human body forms the basis for what we normally see. Understanding how the bones connect allows you to sketch figures more accurately. By simplifying the structure you can use it as a guideline to sketch a figure and align limbs before fleshing out the details.

Elbows are in line with the waist

Sketch feet as simple wedges

Knees line up while sitting and standing

Simplify figure to basic lines for sketches

Sitting Figure

When a figure is sitting, the knees and ankles still line up as if the legs are a folded piece of paper.

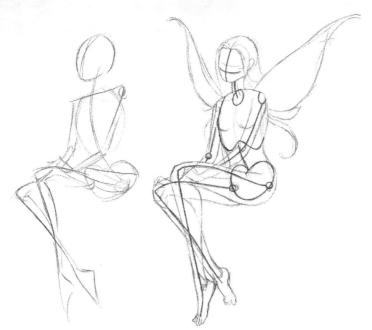

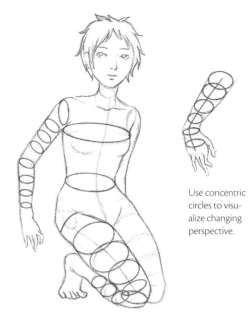

Use concentric circles to visualize changing perspective.

Sitting Fairy Pose

Sketching the entire skeletal form of this sitting fairy first helps to place her limbs correctly even when overlapping means some parts of her will be unseen in the finished drawing. This is especially helpful with life drawing. Since you can't see every angle of a model or photo reference at once, it is essential to know how the underlying forms connect.

Foreshortening

Foreshortening means to render an object so that it appears to recede into the distance. To sketch body parts in perspective, think of body parts as hollow tubes with circular bands along them. Sketch circular band markers to help visualize the mass and volume of the figure.

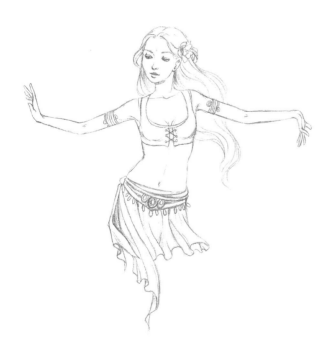

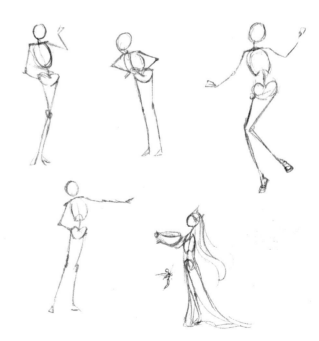

Dance Reference

Studying dancers and gymnasts is a good way to learn both dynamic and graceful poses. The positions of this dancer's hips and shoulders create an S-curve, as do her arms.

Thumbnails

Draw tiny sketches (called thumbnail sketches because of their size) using the most basic skeletal stick figures to experiment with poses and ideas before starting a larger drawing.

Human Proportions

UNDERSTANDING THE PROPORTIONS of the human body is incredibly helpful when you wish to draw and don't have a model handy. These few simple rules will make your figures look more realistic. Comparing the sizes of body parts is the easiest way to check the accuracy of your proportions.

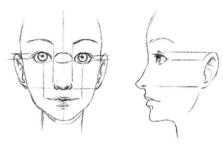

Height and Width
A person's height is closely equivalent to the span of their arms held out at each side.

Figure Heights
The height of your drawing can be measured in heads. Measure the height of a head and sketch out guidelines to mark how tall your figure will be. Typical human height is seven to eight heads high. Women will generally be on the shorter end. You may choose to draw taller, elongated figures for stylistic reasons. For example, fashion model height is closer to eight to nine heads high.

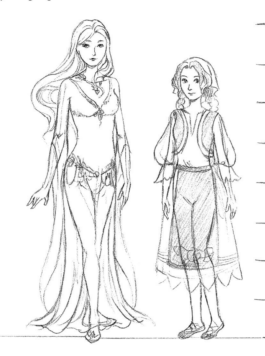

Faces
Use the relationships between facial features to check your proportions.
- One eye width between the eyes.
- The eyes line up with the top base of the ear.
- The nose lines up with the bottom earlobe.
- The corners of the mouth line up with the center of the eyes.

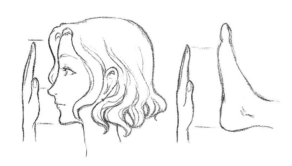

Using Your Hand as a Measurement
Hold your hand up to your face. You will see that the length of your hand spans from your chin to your hairline. The palm is the same length as the space between your chin and nose. Comparing the hand and the foot, the hand is about the length from the heel to the ball of the foot.

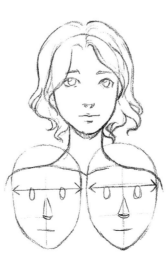

Shoulders
A person's shoulders are about the width of two heads side-to-side.

Drawing the Head

OUR EYES ARE OFTEN DRAWN to a figure in the painting even when it is not the focal point. The human face draws us in as we wonder what the character is thinking and feeling, so learning to draw it from many perspectives is important. Starting with simple shapes, you can practice sketching the head and place the features correctly.

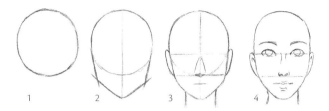

Facing Forward

1. Draw a circle that forms the top part of the head.
2. To add the jawline, first find the center of the circle and sketch a line down through it. Add the peaked line that forms the chin and jaw.
3. Sketch guidelines for the eyes and nose. Draw in a triangle shape for the nose and a line for the mouth below it.
4. Draw the features and erase the guidelines. The features should line up symmetrically along the center guideline.

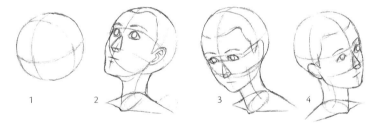

The Profile

1. Draw a circle that forms the top part of the head.
2. Split the circle into four parts. Draw a line for the front of the face. Draw the jawline connecting from the chin to the center line of the circle.
3. Use the guidelines to place the ear above the jawline, and the nose across from the ear.
4. Refine the outline of the face and place the remaining features. Erase any guidelines.

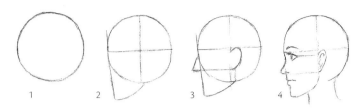

Drawing the Head From Above and Below

Using the sphere shape as a basis, you can draw the head from many angles. As long as you have the guidelines placed, you will know where each of the features should sit. When drawing the nose, think of it as half a cone that is flat on the bottom side.

 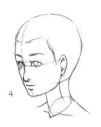

Three-Quarter Views

To draw a three-quarters view of a head, think in three dimensions.

1. Draw a sphere for the base and add guidelines around it. The horizontal guide will always be where the eyes are placed, while the vertical is the center of the face.
2. Add the center guideline and draw the outline of the face on one side and connect the jawline on the other.
3. Draw the nose and ear. Sketch a circle for the base of the neck and a line connecting it to the back of the head.
4. Draw the rest of the features along the center line of the face and guidelines.

Hands

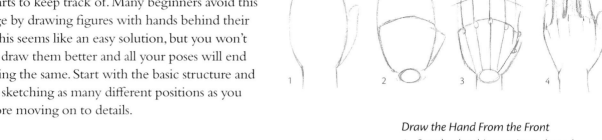

HANDS ARE THE MOST INTIMIDATING part of the human body to draw, simply because there are so many parts to keep track of. Many beginners avoid this challenge by drawing figures with hands behind their backs. This seems like an easy solution, but you won't learn to draw them better and all your poses will end up looking the same. Start with the basic structure and practice sketching as many different positions as you can before moving on to details.

Draw the Hand From the Front

1. Start by sketching a mitten-shaped outline.
2. Outline the palm and a small oval for the wrist. Create a slight point where the middle finger will be. Draw a small triangle jutting off the side for the base of the thumb.
3. Sketch two arched guidelines for the knuckles. These guidelines will always be in the same place no matter the position of the fingers. Draw tendons from the wrist to the first knuckles for each finger. Then draw lines for each finger.
4. Draw the finished hand and fingers.

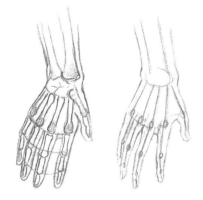

Bone Structure
Study the bone structure of the hand. You don't need to be able to draw all the bones or know their names. But be aware of the places closest to the skin where bones are prominent, like the knuckles and wrist. Simplify drawing the hand by turning the bone structure into simple lines.

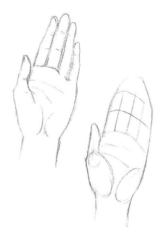

The Back of the Hand
The palm side of the hand has two fleshy oval-shaped pads that start at the wrist. The more prominent one attaches to the thumb and moves with it.

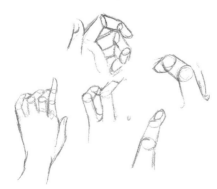

Bending Fingers
When all the sections of a finger are going in different directions it can be a little confusing. With round band markers for the joints, sketch the parts you can't see,.

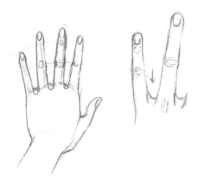

Between the Fingers
When fingers are spread out, there is a wide U-shaped space between them.

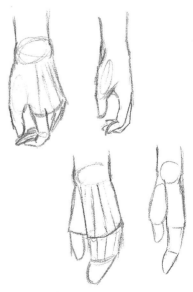

Draw From the Side
When our arms are relaxed at our sides, our fingers are loose and slightly bent.

Feet

FEET ARE MUCH SIMPLER TO DRAW than hands, but there are still some basic rules to keep them from looking lifeless. Even though feet can often be hidden under long, flowing skirts or in simple-shaped shoes, knowing how to position and place them makes the difference between figures floating on the page or standing on solid ground.

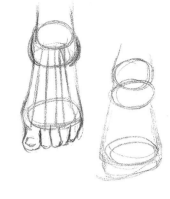

Draw the Foot From the Front

Using a similar method you use for hands, sketch the tendons from ankle to toes.

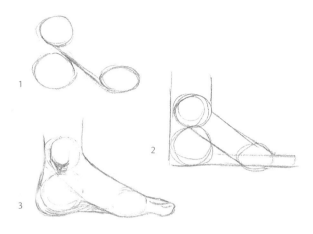

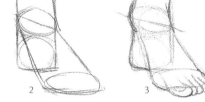

Draw the Side View

1. Sketch a circle for the heel, ankle with a slightly smaller circle for the ankle above it. Sketch a line connecting this to a slightly flattened circle for the ball of the foot. The connecting line becomes part of the bottom arch.
2. Sketch the outline of the heel and bottom, as well as toes projecting out from the ball of the foot.
3. Draw the final outline and add shading. Remember the arch of the inner foot doesn't touch the ground.

Drawing the Three-Quarters View

1. Sketch the three circles like you did for the side view, but place the ball of the foot a little below and to the side of the heel.
2. Sketch an outline of the heel and ankle, then two lines radiating from the anklebone to the ball of the foot. Notice how the front part of the foot overlaps the heel and forms the arch.
3. Finish the outline and details. Make the inner ankle higher than the outer.

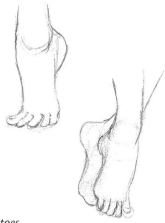

Tiptoes

Draw pointed feet for fairies tiptoeing quietly through the forest. Notice how the small toes curl in while the big toe is flat.

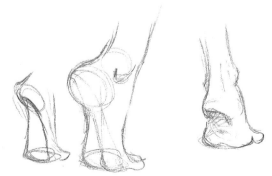

Arched Foot

To draw the back of a lifted foot, use an elongated triangle shape for the sole. The ball of the foot remains on the ground when the foot is arched.

Wing Basics

WHEN DESIGNING A FAIRY CHARACTER, wings will be an important part. Think first about the basic shape and size and then how they will be placed. Inspiration from the natural world of butterflies is a great place to start.

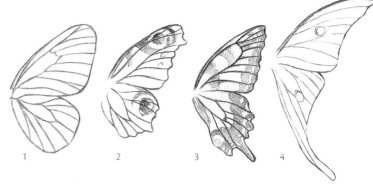

Basic Wing Shapes

1. Begin with a basic moth or butterfly wing with smooth edges. Draw the outline first and then sketch the inner veins. The vein pattern on this wing is typical and can be used for most other shapes.
2. Some butterfly wings have scalloped edges but still follow the basic shape.
3. The swallowtail species has a small tail on the bottom edge.
4. Tails can also be long like this moon moth.

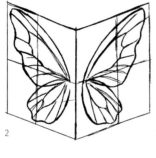

Drawing Wings in Perspective

The wing shape is simple to draw flat but can look static in this position. To draw wings in perspective think of the wings as a folded piece of paper. In fact, this is an easy tool to make for reference.

1. Draw two wings flat, with lines down the center and across. Split each half into quarters.
2. Fold the wings at the center line. Your grid will help you see where to draw the outline.
3. Folded further, the wings become tall and thin, and less detail will be seen.

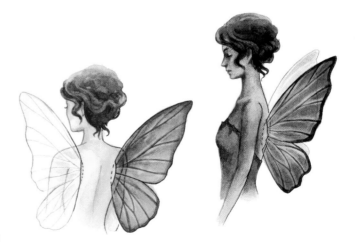

Wing Placement

Wings should be placed along the back between the shoulder blades and the arms. The side view is easiest to draw, as the wings won't be covering anything. When drawing the back view, sketch the entire figure including the parts covered by the wings.

Creative Wings

ALTHOUGH THERE ARE MANY EXAMPLES to reference in the real world, in a fantasy world you should feel free to use colors and shapes that don't exist in nature or to mix and match elements.

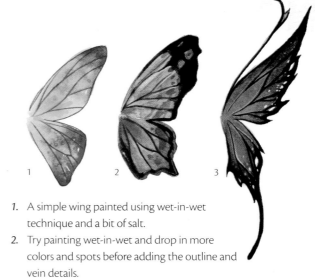

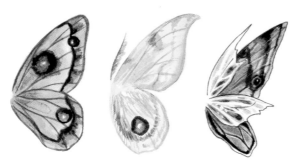

Moth wings have smoother edges, are less colorful and often have a furry texture. Choose colors and patterns that blend into a forest setting. Eye spots mimic the look of predators. For a different look, try combining a moth wing with a translucent wing.

1. A simple wing painted using wet-in-wet technique and a bit of salt.
2. Try painting wet-in-wet and drop in more colors and spots before adding the outline and vein details.
3. Draw an exaggerated shape with long tails, sharp edges and holes for a wild look.

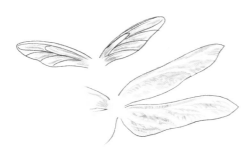

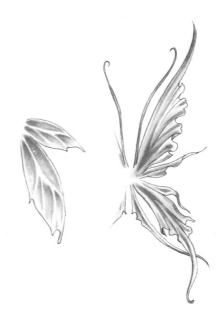

Dragonfly wings are elongated in shape and come in pairs of two or four. Paint them in several layers of transparent colors.

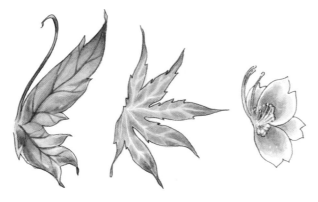

Translucent wings can be any shape. Instead of the tips pointing up, slant them downward to make a ruffled wavy edge, perfect for a mermaid. Leave the white of the paper and paint the sections between with transparent color.

Woodland and garden inhabitants might have wings like their surrounding plants and flowers. Draw wings in leaf shapes or combine them with flower petals and twigs.

Hair

HAIR IS OFTEN the most recognizable trait of a character beside clothing. It can show movement as well as create interest in your composition.

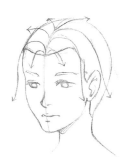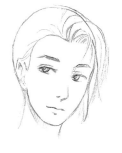

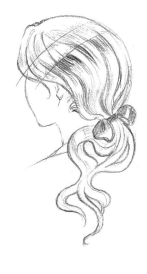

How Hair Falls
Be aware of where the scalp line begins and follow it when drawing hair. Think about how gravity affects it as it falls from the top.

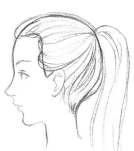

Highlights
Think of a clump of hair like a satin ribbon. When the light hits the highest part, it creates a shiny highlight across the width rather than along the length. The highlights will break up slightly across each clump of hair. When pulled back, the direction of the highlight changes to vertical.

Don't

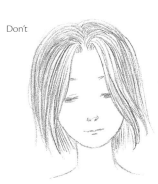

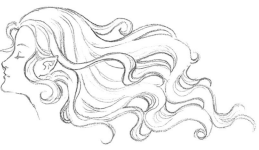

Windblown Hair
When the effects of gravity are released in wind or underwater, hair flows free. Draw flowing waves and curls in many directions. Use this principle to give the impression of a weightless magic realm where gravity doesn't exist. Wet hair will do the opposite and be heavier than dry hair.

Do

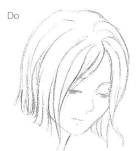

Motion
Show movement by sketching hair so that it follows the head as it turns.

Hairstyles

ANOTHER WAY TO GIVE your character a sense of place is by choosing an appropriate hairstyle. Whether it's simple or elaborate, there are infinite possibilities.

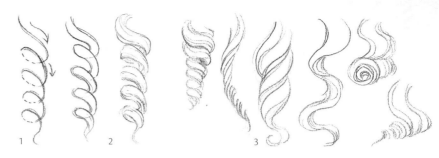

1 2 3

Curls

1. Start by lightly sketching a simple spiral.
2. Make the spiral into a thicker tube or ribbon shape.
3. Thicken and add smaller, irregular clumps of hair.

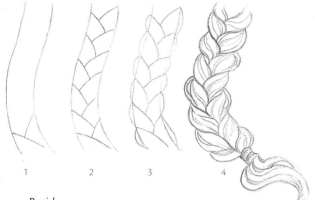

1 2 3 4

Braids

1. Sketch two outer lines for the basic shape. Sketch a diagonal line across the bottom toward the left and another toward the right starting from the center of the first.
2. Continue this pattern along the entire length.
3. Round out the edges of each section of hair.
4. Refine the shape, add a tie at the bottom and indicate detailed strands of hair.

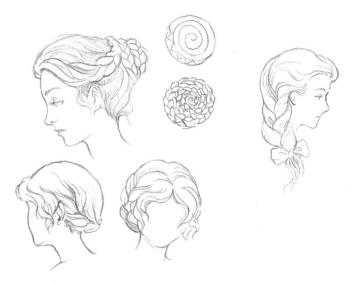

Braid Variations

Rather than just straight braids, try piling them atop the head and twisting them into a spiral or a loose plait instead of a tight one.

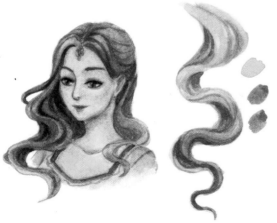

Use Glazes to Color Hair

Paint a curl with a light base color, build up glazes of a medium tone and finally add shadows with a third darker color. For pale hair leave the white of the paper for highlights.

Create contrast by painting stark black hair in an otherwise brightly colored painting.

Choosing a Clothing Style

HOW YOU CLOTHE YOUR CHARACTERS makes an impression on the viewer. Clothing can tell a story of what country or climate they come from, what their occupation is, or how rich or poor they are. Many small details go into creating a complete story. Practicality isn't always taken into account in fantasy art (for example, the sketch below), which can lead to some improbable outfits. If your character works on a pirate ship, long flowing dresses are probably not appropriate, but may make more sense for a fairy or magical being. Dangerous pursuits like fighting dragons require enough coverage to protect the wearer.

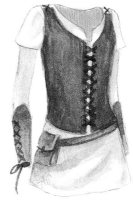

Durable
Leather vests and arm bracers are both practical and durable. Don't forget belts and pouches for travelers to carry supplies.

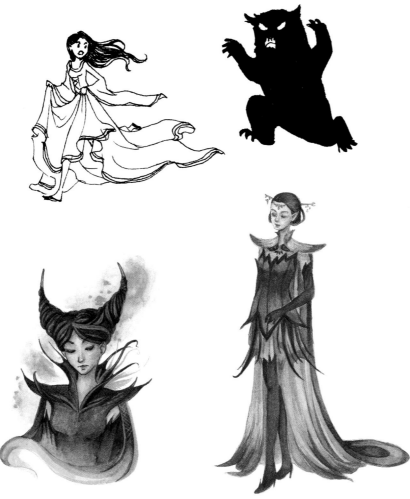

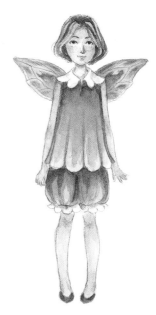

Childlike
Loose simple tunics that are easy to make and mend are appropriate for playful children who are rough on their clothing. Oversized collars and details can make a figure appear smaller and childlike, while rounded forms seem gentle and soft.

A Dark Fairy
Pointy, spiky collars and horn-like hair show she may not be the nice kind of fairy. A wild, impish fairy might have rough, ripped hems and jagged wings.

Elegance
Repeating vertical lines can make figures seem taller, while broad shoulders can make them appear larger or give them a sense of authority.

Ruffles and Ribbons

THESE SIMPLE EMBELLISHMENTS are the start of detailing your fantasy costumes.

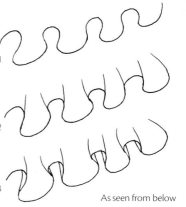

Drawing Ribbons

1. Start by sketching a swirling line.
2. Draw perpendicular lines at the edges of the curves.
3. Connect the sections with a second curved line.
4. Using the same method, create a large ruffle.

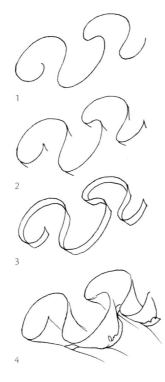

As seen from below

As seen from above

Drawing Ruffles

1. Draw a wavy outline for the bottom edge of the ruffle.
2. Draw vertical lines to indicate the edges of each fold.
3. Add lines indicating the underside of each fold.

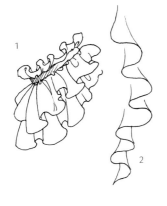

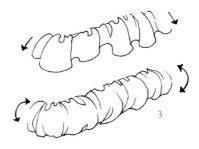

Ruffle Variations

1. Fabric gathered in the center creates top and bottom ruffles.
2. Drawn vertically, the folds fall stacked over one another.
3. A basic ruffle is gathered and sewn at the top. Gathered at the top and the bottom, it creates a puffed-up shape.
4. Pleats are basically ruffles that have been pressed.
5. Combine a detailed lace edge with a ruffle.

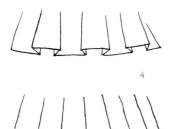

Historical Costume Silhouettes

FAMILIARIZING YOURSELF with the basic silhouettes of each era will allow you to create your own fantasy interpretations by adding a little creativity.

INSPIRED BY ANCIENT GREECE

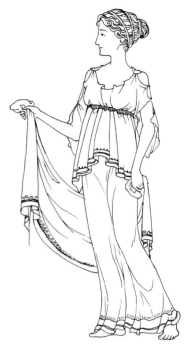

Ancient Greek
The basic silhouette is straight and long with a waistline placed high.

The ancient Greek dress is a loose tunic gathered above the waist and pinned at the shoulders. It gets its characteristic look from the many accordion folds created.

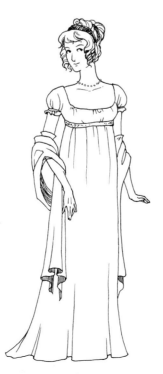

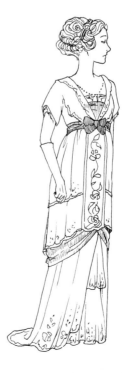

Neoclassical and Regency
An eighteenth-century take on ancient Greek styles. It follows the same shape but with more modern tailoring.

Edwardian
An early twentieth-century style dress (circa 1910) has a high waist, is loose and has a simple shape compared to earlier Victorian styles.

MEDIEVAL TO RENAISSANCE

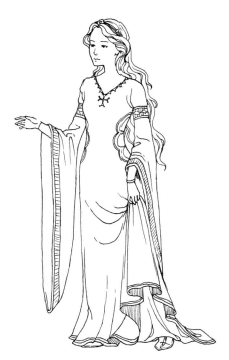

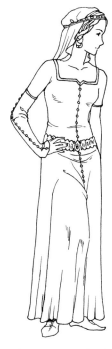

The basic medieval silhouette is fitted at the top with a skirt that hangs from the hips and flares at the bottom.

A twelfth-century dress with long, loose sleeves and multiple layers.

A fourteenth-century cotehardie dress is fitted with buttons down the front and sleeves.

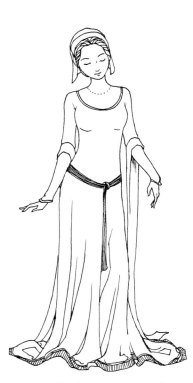

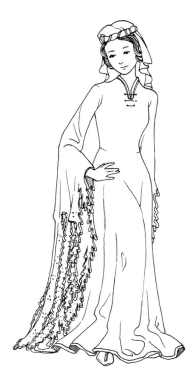

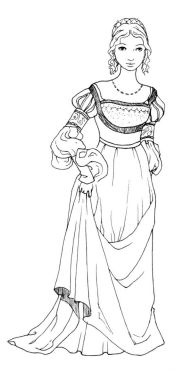

Long, ribbon-like sleeves hang from the elbows on a fourteenth-century dress.

The scalloped edges on this dress are from the fifteenth century.

An early sixteenth-century dress shows the beginnings of Renaissance style with puffed sleeves and a slightly fuller skirt.

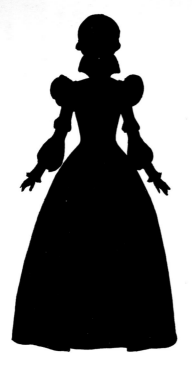

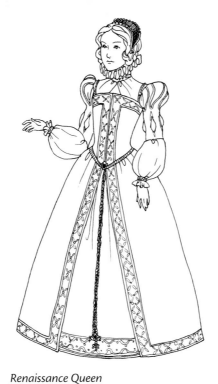

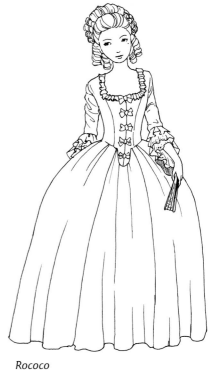

The basic silhouette has an inverted triangle-shaped bodice joining a triangle- or bell-shaped full skirt.

Renaissance Queen
This sixteenth-century Renaissance dress has slashed sleeves, a high collar and embroidery along the edges.

Rococo
A late eighteenth-century dress is wider at the hips, has a lower neckline and bell-shaped sleeves starting at the elbows.

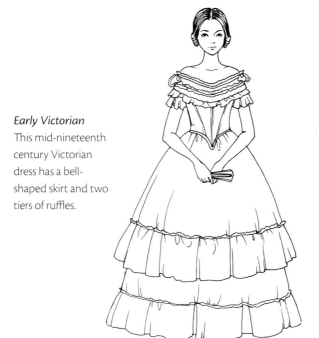

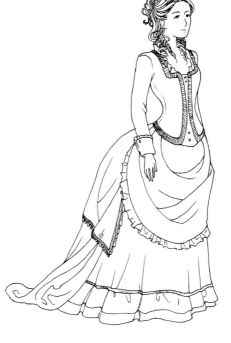

Early Victorian
This mid-nineteenth century Victorian dress has a bell-shaped skirt and two tiers of ruffles.

Late Victorian
A late nineteenth-century Victorian dress features a bustle and is straight in the front and curved in the back. The overskirt is gathered.

EAST ASIAN

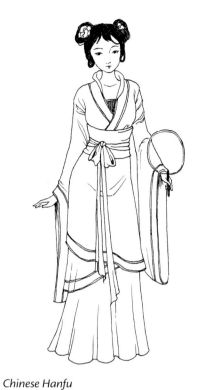

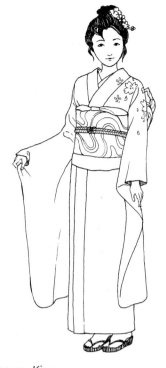

The basic silhouette is straight and robe-like. Sleeves are usually long and hanging. The traditional Han Chinese dress forms the basis for the later styles.

Chinese Hanfu
An early Chinese dress is a robe tied at the waist with long, flowing sleeves, often with a skirt beneath.

Japanese Kimono
The kimono is straight and rectangular to the point of obscuring any body shape.

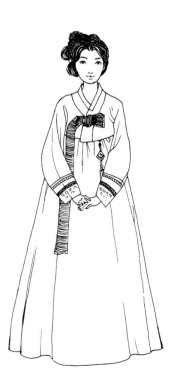

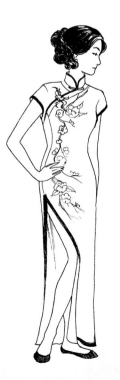

Korean Hanbok
A short, robe-like jacket with curved sleeves. The skirt is long and flared.

Cheongsam
A modern one-piece Chinese-style dress is long and fitted with a straight skirt.

Drapery and Folds

TO PRACTICE DRAWING FOLDS, try draping a sheet or clothing over a chair or hanging it from a hook. Depending on the weight of cloth you use, the folds will be different. Lighter fabric will create many small folds, while heavy fabric will fold less. Observe how it acts on flat surfaces and how it falls.

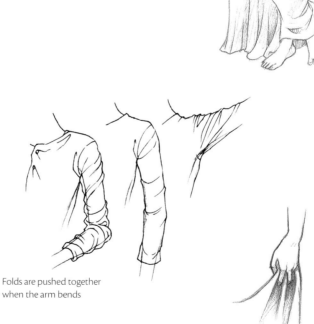

Folds falling from the shoulder break the folds from the elbow

A belt creates gathered folds

Straight accordion folds fall from the hip

Fabric rests on the flat surface of the raised leg

Wind
Windblown cloth twists and turns in many directions. Use it to show a figure's movement and add interest to a composition.

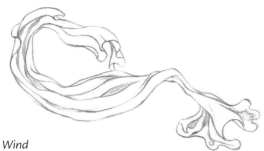

Don't Do

Vary the shapes and draw irregular folds.

Folds are pushed together when the arm bends

Movement
Observe how limb movements affect folds. When the arm is bent, folds bunch up by the elbow. There are few folds when the arm is straight. As the arm rises, it pulls the cloth and creates folds at the shoulder.

Fold created by the pull of a button

Pulled Cloth
Folds radiate from what causes them, whether a hand, seam or button.

Drawing Patterns on Folds

Don't

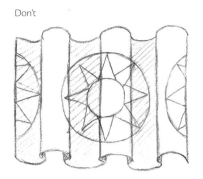

Do

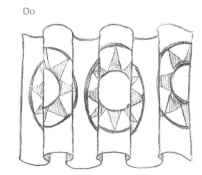

Don't draw the pattern right over the folds.

Simple Stripes

1

2

3

4

1. Sketch the pattern as it lies flat.
2. Sketch the fabric with a slight wave. Notice how the stripe follows the bottom curve of the fabric.
3. Add more waves. The pattern still follows the edge, but you don't see the backside of each curve.
4. Try drawing the fabric folding back on itself. There are now larger unseen sections.

An Organic Pattern

1

2

3

4

1. Sketch a large organic pattern across the fabric. Break the pattern into sections resembling lined paper.
2. Sketch the design as if the paper has been folded like a fan.
3. Folding it further, observe how some sections are hidden from view.
4. The crisp folds are easily changed to rounded drapery.

Collars and Trims

ADD DETAIL TO A COSTUME by using a unique collar or edging. Choose a design that brings to mind a particular historical era or create something unique.

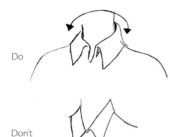

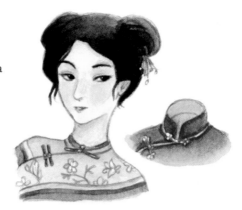

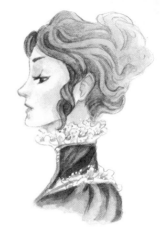

Do

Don't

Pay attention to how the collar curves all the way around the neck.

A Mandarin-style collar common on Chinese traditional clothing folds over from one side and uses elaborate ribbon clasps.

A high ruffled collar gives an extra air of formality.

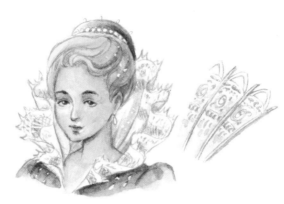

A stiffly starched Renaissance ruff is perfect for a princess who doesn't worry about practicality.

DRAWING LACE

Intricate lace patterns can be simplified and easy to draw. When drawn smaller, you can simplify them even more to a series of loops or scallops to create the impression of detail.

1

2

3

1. Sketch a simple scalloped edge in one or more layers.
2. Outline the main forms.
3. Add crosshatches and loops to indicate connecting threads.

Vary your lace with recognizable shapes like flowers or leaves, or use it at the edge of ruffled cloth.

BASIC PAINTING TECHNIQUES

Jewelry

SPARKLING JEWELS AND GLEAMING METALS are a perfect way to add eye-catching details to a fantasy painting, whether it's a fairy clad in flowers or a princess with golden jewels.

Don't be afraid to draw elaborate designs that wouldn't work in real life. Understanding the materials used can help you mark a time and place or show an otherworldly style for a fairy or mermaid.

Sketch Jewelry
1. To design a piece using organic shapes, first sketch the main shape. For a crown, draw a foreshortened oval. Lightly sketch loose swirls and swoops over the main band.
2. Pick out shapes in your sketch and refine the outline with darker pencil or ink. Add more details like overlapping shapes or jewels as you practice.

Gems and Stones
Different types of gemstones are associated with historical periods. Choose one that defines your character by thinking of the tools available to them.
1. Ancient jewelry was made from animal bones, shells, carved wood and easily found natural materials.
2. A river-polished or tumbled stone is shiny and smooth but still rough in shape. Many stones were set in their natural shapes in early civilizations.
3. A cabochon is polished and rounded on top while flat on the bottom and was most common until the 1400s. Cabochons are simple to draw and are a good choice for medieval-style jewels.
4. Cut gems are inspired by the natural shape of crystals and a Renaissance fascination with light. Faceted gems appeared with advances in cutting tools in the thirteenth and fourteenth centuries. Early cut gems are simple and contain fewer facets than modern styles.

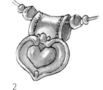 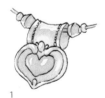 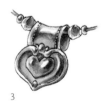

Paint Silver
1. Mix very pale Payne's Gray with a little Cobalt Blue. Lightly paint strips of color on the band and around the spiral. You can easily add more paint at the end, so leave plenty of white.
2. Using less water, darken the shadows, painting the darkest areas where the reflection touches the white highlight, and soften the bottom edges of each area.
3. Add the darkest areas with Payne's Gray around the spiral and against the white highlights. This contrast gives the impression of silver.

Paint Gold
1. Paint a layer of light Yellow Ochre over the pendant, leaving white spots for highlights on the peaks of each shape.
2. Mix Burnt Sienna with Yellow Ochre for the medium values. Add shadows around the rounded forms opposite the light source. Paint the darkest areas adjacent to the highlights.
3. Deepen the shadows by adding Dioxazine Purple to the previous color mix.

PART TWO

Inspired by Nature

*I*T IS ONLY NATURAL to find inspiration in the world around us. Since the beginning of time, humans have explored the natural world, combining it with their imagination to create art. From the ancient cave paintings of Lascaux, to towering cathedrals carved with animal faces, or manuscripts overflowing with twisting vines, artists captured the majesty of nature for ages to come. Look to the gardens beneath your feet, the sparkling skies above you and the flowing waters of the oceans to inspire fantastical costumes.

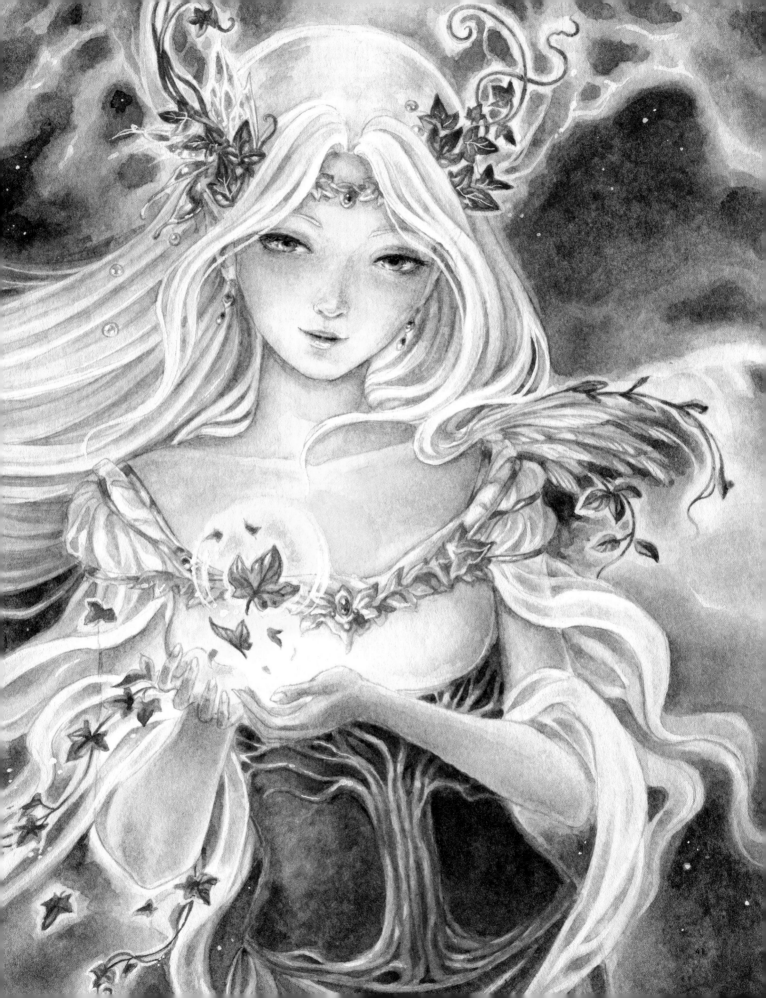

Flowers and Leaves

PAINTING THE NATURAL WORLD is vital to create convincing paintings of faery creatures. From depicting their forest surroundings to their clothing—the fae world is full of minute details that often go unseen, except for those small enough to spot them.

1. *Basic Shape:* Sketch a simple spiral shape in light pencil.
2. *Define the Shape:* Use ink or darker pencil to draw a small C-shaped petal at the center. Following the spiral, add overlapping petals, slowly making them larger.
3. *Finish the Form:* Draw the open outer petals and erase the sketch underneath.

Five-Petaled Flowers
Flowers containing five petals similar to a star shape are common. This crab-apple blossom can be divided into equal parts. There are endless variations of shapes, colors and overlapping forms.

Iris
The iris petal has an elaborate shape reminiscent of ruffles, with a furry yellow mane. Paint the main color with light Ultramarine Violet, deepest in the center and fading to white at the edge, and Quinacridone Violet at the top. Paint the thin veins with Dioxazine Purple. Depict the mane by painting dashes of Cadmium Orange over Cadmium Yellow.

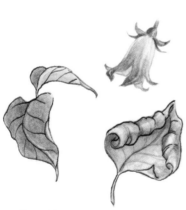

Small Details Matter
Leaves and petals aren't identical and don't keep their shapes forever. Vary the shape and angle to avoid repetition when depicting foliage. Older blooms and leaves will dry out from the edges inward, curling and changing in color. Including a little imperfection looks more natural.

Fruit Tree Leaf
Lay down a base of Sap Green mixed with Cadmium Yellow, leaving space for the center vein. Glaze Viridian over each side and blend toward the edges. Detail the sections between each leaf with short strokes of Hooker's Green.

Autumn Leaf
Working wet-in-wet, paint a layer of Cadmium Yellow over the whole leaf. Then drop in bits of Cadmium Orange and Red at the tips and Sap Green at the base. When dry, paint in the veins with Cadmium Red and darken the tips and sections between veins by glazing with a lighter layer of red.

Botanical Clothing

FAIRIES LIVE AMONG PLANTS, so it's only natural to take their clothing cues from their surroundings. Think about the shape of plants you look at, and what they might become. Be creative with alternate uses a fairy might have for stems, petals and leaves. Don't be afraid to go out and take photos and collect samples to examine. Taking apart a flower and looking at the individual parts can be inspiring.

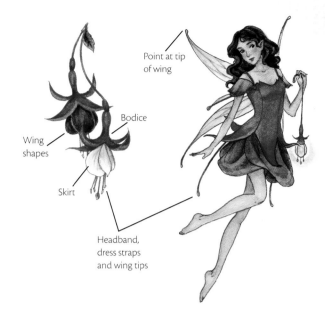

Point at tip of wing

Bodice

Wing shapes

Skirt

Headband, dress straps and wing tips

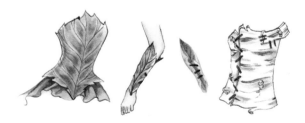

Fairy Skirts

A tulip or daffodil turned upside down easily becomes a flared skirt, while other petals can be layered. Smaller bell-shaped flowers can be used as sleeves. Look for striking patterns of veins and coloring or petals with ruffled or fringed edges for a more exotic look.

From Flower to Fashion

Examine your chosen plant and brainstorm uses for each part. This fuchsia already resembles a tiny fairy figure. The shape of the red outer petals easily becomes a dress, while the inner petals become a ruffly layered skirt. Her wings follow the shape of the red petals.

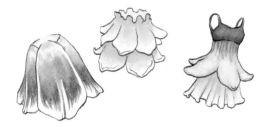

Using Leaves and Bark

For costumes with a more subdued palette of greens and browns, look to trees for inspiration. Observe how leaves often curl when dried or dead. Leaves are sturdier than petals, so they can be wrapped, curled and fastened around arms and legs. Thick tree bark might be armor, but curling birch bark is more flexible. A forest fairy might wear a crown of leaves and berries or a bodice made from one large leaf. Colorful autumn leaves can be striking.

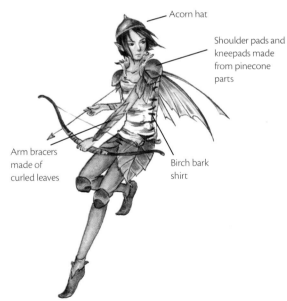

Acorn hat

Shoulder pads and kneepads made from pinecone parts

Arm bracers made of curled leaves

Birch bark shirt

The Forest Floor

Look past fallen leaves on the forest floor and you may find things you didn't know there. Tiny mushrooms, lichen, soft moss, acorns, pinecones, fallen berries and seedpods can all become fairy clothing. Acorns make excellent hats, and pinecones might be taken apart and used as shoulderpads or kneepads.

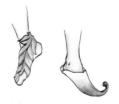

Fairy Shoes

A small leaf wraps around to create a foot covering, and an inner columbine petal makes a cute and delicate curly-toed slipper.

PAINT A FLOWER FAIRY

TRANSPARENT WINGS

*F*AIRY WINGS ARE INSPIRED by real insect wings, which are often transparent. Learning how to paint glass–like wings through which you can see the background will create depth in your painting.

MATERIALS

assorted brushes

cold-pressed watercolor paper

pen, pencil and black waterproof ink

PAINT

Burnt Sienna

Cerulean Blue

Sap Green

Ultramarine Violet Deep (or
 substitute Ultramarine Violet)

Yellow Ochre

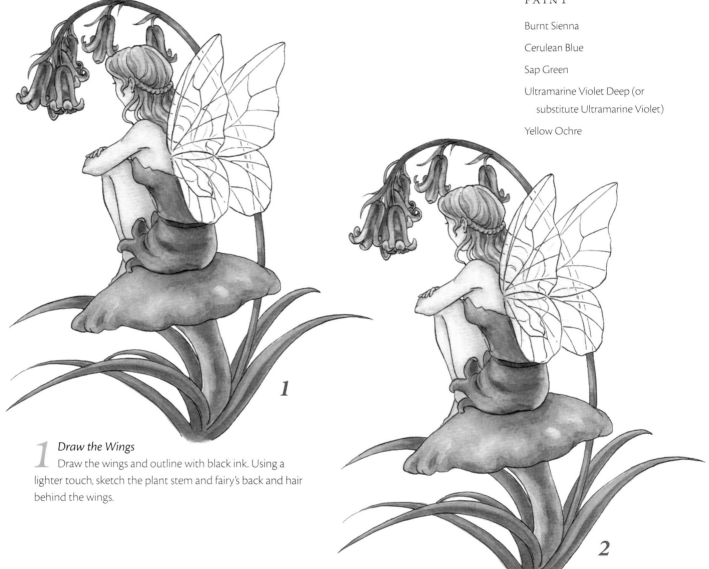

1 Draw the Wings
Draw the wings and outline with black ink. Using a lighter touch, sketch the plant stem and fairy's back and hair behind the wings.

2 Begin Shading the Wings
Shade the base of the wings with very light Ultramarine Violet Deep. Blend toward the center with clear water. Make the darkest color at the base.

3 Shade the Outer Edges

Line the outer edge of the wings using Ultramarine Violet Deep and blend toward the center with clean water. Keep the center of the wings the lightest.

4 Paint the Objects Behind the Wings

To make the fairy's wings appear transparent, paint the objects behind the fairy's wings a lighter color. Using short strokes, apply color to the stem with Sap Green. Leave thin, white areas around the wing veins. Do the same with a mix of Yellow Ochre and Burnt Sienna on the hair, making it lighter under the far wing. Use Cerulean Blue on her dress.

5 Add Detail

Using the same colors, add darker areas to the stem, hair and dress. Use short strokes to paint the darker spots on the stem between each wing section. Blend each spot with clear water toward the bottom. Do the same with the dress and areas between strands of hair.

6 Create Depth

With Ultramarine Violet Deep, shade the top of each section of the wings, blending the edges away. Be sure to leave a thin line along each vein unpainted. Use another layer over the darkest areas of the other colors.

7 Finish the Wings

Deepen the darkest areas of violet on the wings with Cerulean Blue and soften the edges with clean water.

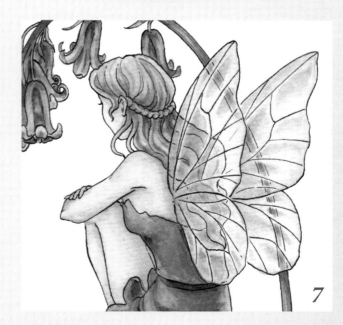

CREEPING BELLFLOWER

A SMALL FAIRY WITH A GOLDEN BRAID dances among the leaves of her favorite flower. The Creeping Bellflower, or Rampion Bellflower, is a common wildflower. Painting a simple background with two main colors will allow the fairy and her flower to be the stars.

MATERIALS

assorted brushes

hot-pressed watercolor
 paper

pencil and waterproof ink

salt

PAINTS

Burnt Sienna

Cadmium Yellow

Cerulean Blue

Cobalt Blue

Cobalt Violet

Dioxazine Purple

Hooker's Green

Lamp Black

Payne's Gray

Phthalo Blue

Quinacridone Red

Quinacridone Violet

Raw Umber

Sap Green

Ultramarine Violet

Viridian

Yellow Ochre

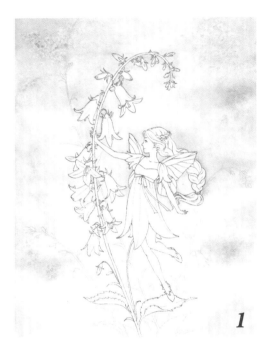

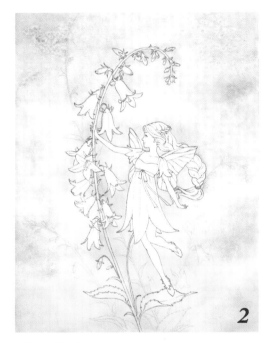

1 Create the Misty Background
Sketch the wildflowers and fairy in pencil. Use waterproof ink to outline the elements in the foreground. Mix Cobalt Violet and Cerulean Blue, then paint around the edges of the fairy and foreground flowers, and blend toward the paper edge. Leave the bottom section near the plants white. Wet the area around the figure and plants from top to bottom. Make a wash of light Cobalt Violet at the top and center. While still wet, drop in bits of darker Cobalt Violet and the mix of violet and blue at the top corners and sides. Sprinkle salt over the darkest areas while wet and let dry.

2 Add a Sap Green Glaze
Paint a very diluted Sap Green around the central flowers and figure. Avoid the flowers, but paint lightly over the leaves and stem. Then paint a light wash of green on the bottom third of the background, blending upward.

3 Paint the Foliage

Use Sap Green on the central stem. Mix with Cadmium Yellow for the leaves near the tip and over the background stems. Add more yellow on the smaller buds. Keep the background plants lighter than the central stem. Paint a mix of Sap Green and Viridian over the top side of the largest leaves and bottom half of the stem. Paint the underside of the leaves with the green and yellow mix.

4 Paint the Flowers and Wings

Start with a wash of very light Ultramarine Violet on the blossoms, dress and shoes. Paint the darkest value at the tops of each bell (where the bell meets the stem). Blend the color out at the edges. Make a light wash of Ultramarine Violet over the dress and, while still wet, add more to the waistline and shoulders, blending downward. Paint the fairy's wings with Phthalo Blue. Leave white around the outer edge. Glaze another layer near the base of the wings.

5 Make the Colors Deeper

Shade the outside and inside of the bells and folds in her dress with Ultramarine Violet. Paint the dress so the folds resemble flower petals, placing the darkest value at the center of each section and blending out to the edges. Make the entire ribbon and her shoes darker. With Cerulean Blue, paint the sections between the veins on her wings. Darken with another layer of the same color by painting near the base and along the outer edges. Blend toward the center.

6 Finish the Wings

Glaze a layer of Quinacridone Violet between the veins at the outer half of the wings. Then outline the edges with Payne's Gray, blending toward the center. Paint a very thin line of Lampblack around the edge and outline the outer edge of the veins.

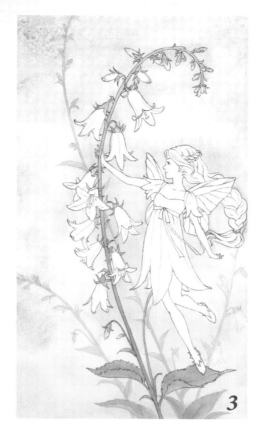

3

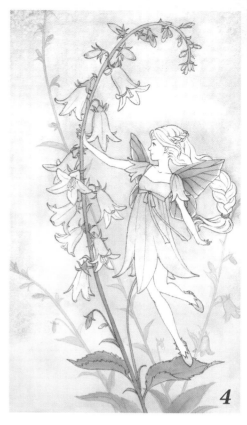

4

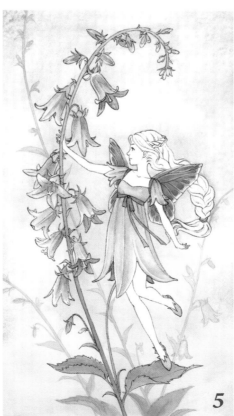

5

6

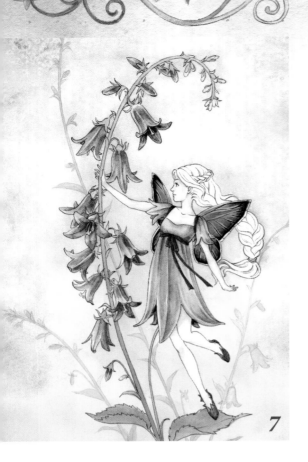
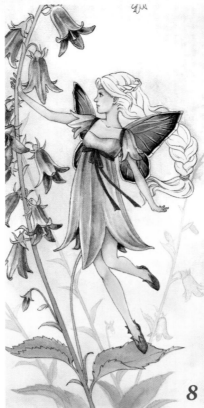
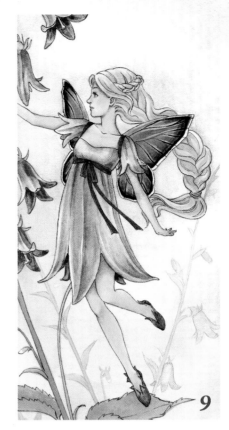

7

7 *Make Shadows and Begin the Skin*
Darken the folds on the fairy's clothing and blossom shadows with a mix of Dioxazine Purple and Cobalt Blue. Begin adding very light shadows to the skin with a pale mix of Ultramarine Violet and Dioxazine Purple. Consider adding shadows beneath the skirt and sleeves, under the chin and hair, and along the left sides of the arms, legs and knees.

8 *Work on the Skin and Hair*
Paint the skin with a very diluted mix of Cadmium Yellow with a tiny bit of Quinacridone Red. Mix in more red and glaze lightly over the purple shadows previously added to the skirt and sleeves. Next, mix Burnt Sienna with a bit of Quinacridone Red. Use this to darken the deepest shadows. Add blush to the cheeks, knees, fingertips and nose with very light Quinacridone Red. Use light Yellow Ochre to paint a flat wash over the fairy's hair.

9 *Deepen the Hair Color*
Glaze a mix of Yellow Ochre and Burnt Sienna over the hair between strands and sections of her braid.

10 *Glaze the Flowers and Finish the Hair*
Glaze the flowers and fairy's dress: Paint over the lighter parts with diluted Quinacridone Violet. Glaze over the darker areas and folds (the parts that were previously painted with the darkest purple) with Cerulean Blue.
Add detailed strands of hair with Yellow Ochre mixed with Burnt Sienna. For the darker strands, use more Burnt Sienna mixed with Raw Umber (for best results, mix a bit more Burnt Sienna and a bit less Raw Umber).

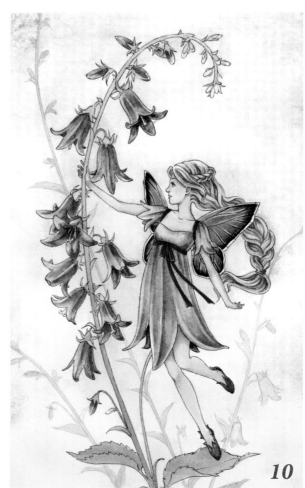

10

For more lessons using natural elements, go to impact-books.com/fairy-fantasy.

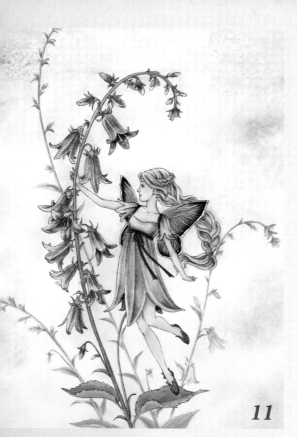

11

Build up Shadows on the Foliage

Shade the central flower stem with a mix of Sap Green and Hooker's Green. Paint the outer edges of the stalk, being careful to leave a sliver of lighter color in the center. Paint the top sides of the large leaves at the bottom while leaving the vein in the center. Shade the background stems and leaves with a lighter Sap Green. Add light shadows on the background blossoms and buds with Ultramarine Violet.

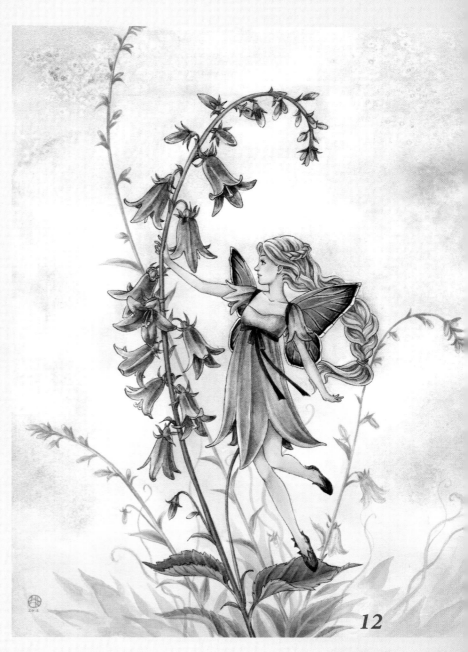

12

Add the Final Details

Paint faint background leaves and stems at the bottom of the image using Sap Green. Blend leaves toward the bottom. Darken the central stem and add details to leaves with Hooker's Green. Mix Hooker's Green with Dioxazine Purple for the darkest shadows on the leaves and stems. Add shadows under the fairy's knees with pale Quinacridone Red and darken her shoes and ribbon with Payne's Gray.

Trees and Foliage

TREES ALWAYS MAKE GOOD BACKDROPS for fantasy paintings, whether it's a dark forest or a single sapling in a dewy field. Twisting branches can become forest spirits and dryads.

Trees can convey a wide variety of atmospheres— a solemn and stout old oak evoking timeless stability, a gnarled and leafless trunk erupting from the ground like dark magic lightning, a jolly old uncle willow with a giant mop of leaves. There are endless options for finding the tone you want your background to set.

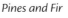

Sketching Trees

Though many trees grow straight like the first tree, it's not a very interesting drawing. Draw asymmetrical forms for a more engaging composition or to draw the viewer's eye.

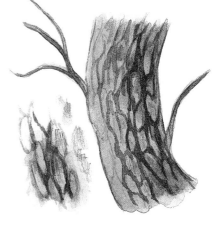

Foliage

Painting every leaf on a tree can be tedious, so make a few detailed leaves in the foreground. To give the impression of full foliage, hold a round brush sideways and make short downward strokes, varying the colors from light to dark.

Pines and Fir Trees

A pattern of separate scale-like sections is common on pines. Paint the base color with Burnt Sienna and drop in some spots of Payne's Gray while it's still wet. Outline a series of rough, elongated shapes vertically with Burnt Umber and Sepia. To give the bark a rough texture, drybrush more Burnt Sienna in a few patches.

Birch Trees

Birch bark is smooth and papery with a horizontal pattern of short gray and black streaks. Darker black diamond-shaped areas appear where branches sprout. Use very pale Payne's Gray to give the trunk form. Paint short light gray strokes across the tree. Use a dry brush to paint darker marks with Payne's Gray or Lamp black. Where the bark peels away, paint the exposed layer with very light Burnt Sienna.

Background Branches

A simple way to add depth to a forest scene is to paint shadow branches behind the main elements. Paint the silhouettes of branches or trees in the distance with a paler color than on the close trees. Paint wet-on-dry for sharp lines and wet-in-wet for a less-focused background.

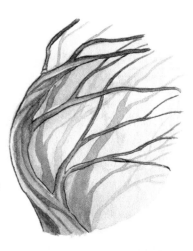

A Forest Background

COMBINING THE INDIVIDUAL TECHNIQUES for painting trees and foliage will allow you to create an enchanting forest setting.

MATERIALS

assorted brushes

hot-pressed watercolor paper

pen, pencil and waterproof ink

PAINTS

Burnt Umber

Cobalt Blue

Hooker's Green

Payne's Gray

Sap Green

Yellow Ochre

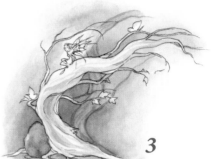

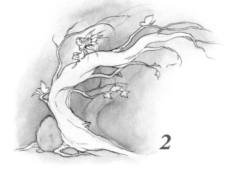

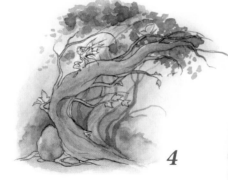

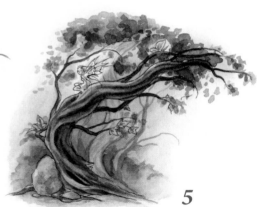

1 Paint the Background Base Color

Sketch the trunk and fairy. Outline the foreground elements with ink while leaving the background tree in pencil. Paint Sap Green around the tree. Paint very pale Sap Green over the trunk, but avoid the fairy and the moth.

2 Add More Color

Paint a little bit of light Yellow Ochre around the fairy and the moth. Then mix Cobalt Blue with Sap Green to deepen the background color. Use a light hand on the tree in the distance to distinguish it from the background.

Paint the small areas between branches. Paint a light layer of Payne's Gray over the rocks and ground.

3 Add Depth

Use Cobalt Blue to outline the background tree and darken the area around it. Use a very light mix of Cobalt Blue and Sap Green to begin painting bark texture on the primary tree. Darken the rock with more Payne's Gray and drop in a few spots of clear water for texture.

4 Create Foliage

Paint the central tree with Burnt Umber, and add more Yellow Ochre around the fairy and the moth. Paint the main leaves in Sap Green.

Paint the outline of distant foliage behind the base of the main tree with a mix of Cobalt Blue and Hooker's Green. Blend the color so it fades toward the bottom. Paint thin shadow trees and branches with the same color.

Dot leaves around the top, using Hooker's Green, to make a mass of foliage. While wet, drop in spots of Sap Green.

5 Finish the Details

Create shadows on the main tree with darker Burnt Umber. Add deeper crevices in the bark by using Burnt Umber mixed with Cobalt Blue.

Add depth to the top foliage by dotting some darker spots with Hooker's Green mixed with Cobalt Blue. With Sap Green add details to the front leaves and dot more around them.

Finish by adding shadows to the fairy and the moth with very light Burnt Sienna, and paint a few rough spots of Payne's Gray over the large rock.

BIRCH MAIDEN

*I*N GREEK MYTHOLOGY, dryads are female tree spirits, who live in forests and are fond of oak trees. Hamadryads live in or are connected to a particular tree. They are quite shy and do not stray far from their trees. A wood nymph may take the appearance of a young maiden or share the form of her tree.

The straight-growing birch, colored in stark black and white, creates a striking contrast to the colorful leaves around it. As well as their distinctive look, birch trees have a long history of association with spring and new life, often used as the maypole on May Day. The Tree Spirit dons the same autumn colors with clothing that echoes that birch paper bark and seedpod shapes.

MATERIALS

assorted brushes

hot-pressed watercolor paper

pen, pencil and water-proof ink

PAINTS

Burnt Sienna

Burnt Umber

Cerulean Blue

Cadmium Red

Cadmium Yellow

Dioxazine Purple

Hooker's Green

Payne's Gray

Quinacridone Red

Quinacridone Violet

Sap Green

White Gouache

Yellow Ochre

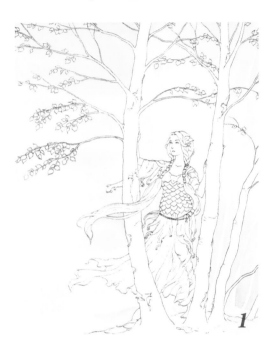

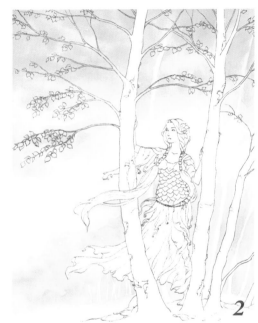

1 Begin Laying the Background Wash
Paint very pale Yellow Ochre over most of the background, but leave some white space for distant tree trunks. Mix in a little Burnt Sienna and paint the top and bottom of the composition between the trees.

2 Paint a Base Layer for the Foliage
Wet the top between the trees and drop in a mix of Yellow Ochre and Burnt Sienna between the branches where you want leaves. Continue to leave some unpainted white space for distant tree trunks. Add a little Quinacridone Red to the mix in a few random spots.

Paint between the trees midway to the bottom with a lighter mix of Burnt Sienna and Yellow Ochre, and paint the overall shapes for the trees in the distance on the bottom left.

3 Add Green Tones to the Background Trees
Paint the ground at the bottom right corner with a mix of Sap Green and Yellow Ochre. While wet, drop in Yellow Ochre at the top edge and Cerulean Blue and Dioxazine Purple at the bottom edge. To paint the small background trees, paint the areas between the trunks with another layer of Yellow Ochre. While still wet, drop the Sap Green and Yellow Ochre mix in the treetops for a mottled look. For

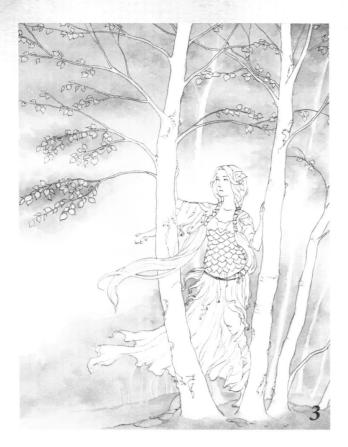

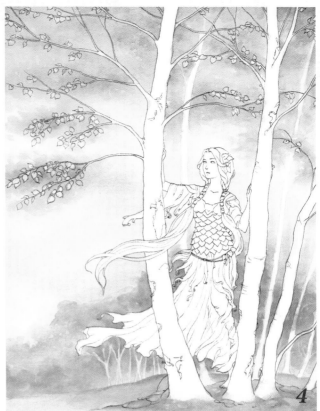

variation, randomly add a little Hooker's Green in the lighter green areas just painted.

Paint the foliage at the top with the Yellow Ochre and Burnt Sienna mix. Leave some spots open to indicate spaces between leaves. Use clean water to soften some of the edges. Working wet-in-wet, mix in a little Quinacridone Violet with the previous color for darker foliage. Paint with varying colors, using the darkest around the branches and leaves.

4 Deepen the Green Tones
Add more light Yellow Ochre around the middle section of the background and between the trees.

Mix Sap Green with Cerulean Blue and paint the uneven texture on the ground by painting round rock shapes and then softening the edges with water. Then paint the same color on the background trees, making the most intense color in the center.

5 Give Dimension to the Tree Trunks
Bring the background colors in from around the trees to shade each trunk. Paint along the sides of the trunks, with darker shadows along the left side. Use Yellow Ochre and Burnt Sienna near the top and greens and blues toward the bottom. Paint along the length and leave a white space for backlighting along the right side. Use the same colors to shade the birch bark on her skirt and sleeves.

Add more foliage to the top by dabbing a few layers of various mixes of Yellow Ochre, Burnt Sienna, Quinacridone Violet and Cadmium Red. Then add more shadows to the background forest with Sap Green mixed with Cerulean Blue.

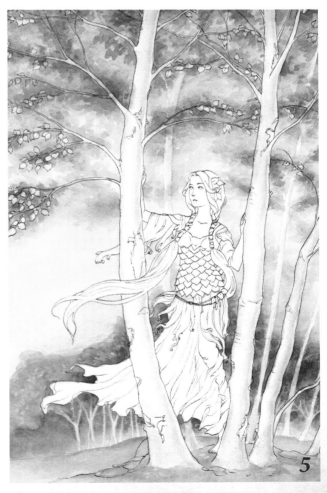

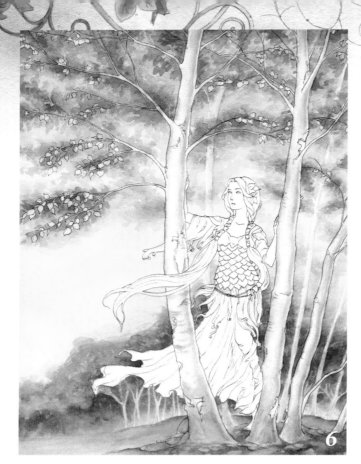

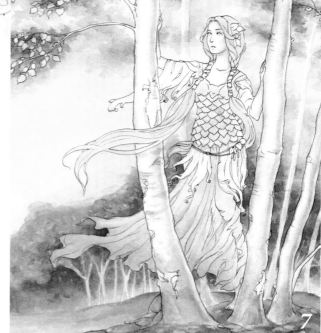

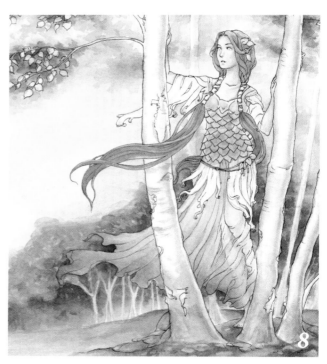

6 Build up the Foliage

Glaze Payne's Gray over the shadows on the tree trunks with short sideways strokes. Do a heavier coat at the bottom of each tree. Deepen the shadows with Cerulean Blue mixed with Dioxazine Purple. Add in Sap Green for the areas on your left.

Use Sap Green mixed with Cerulean Blue to deepen the color on the background foliage.

7 Paint the Figure

Paint shadows on her skin using light Dioxazine Purple. Mix in a little bit of Sap Green for the darker parts of the shadows.

Paint Yellow Ochre over her skirt, then mix in a little Sap Green at the top and Burnt Sienna near the bottom. Color her hair and bodice with Yellow Ochre.

(A bit about shadowing: shadows usually fall on the opposite edges of objects from the location of your light source. In this case the light is coming from the top right, so most shadows will be along the left edges of the figure and the tree trunks.)

8 Glaze the Skin and Build Color on the Clothes

Glaze a light mix of Cadmium Yellow and Cadmium Red over her skin. Paint diluted Yellow Ochre mixed with Burnt Sienna in the folds on the bottom half. Dab this color in spots over her bodice, then shade the top and the leaves on her belt and head with Yellow Ochre. Use the same color to darken her hair while leaving space for highlights. Mix in a little Quinacridone Red and paint around the bottom edge of the skirt. Blend toward the center with water.

9 Glaze the Skin and Hair and Add Detail to the Dress

Glaze light Cadmium Red over her skin, following the painted shadows. Use pale Quinacridone Red for the pinker areas like her cheeks.

Add darker values between locks of her hair with Burnt Sienna, and mix in Burnt Umber for the color at the ends and in the deepest shadows.

Paint a mix of Sap Green and Yellow Ochre at the top of her skirt. Use varying mixes of Burnt Sienna, Quinacridone Red and Quinacridone Violet to deepen the folds at the bottom. While the

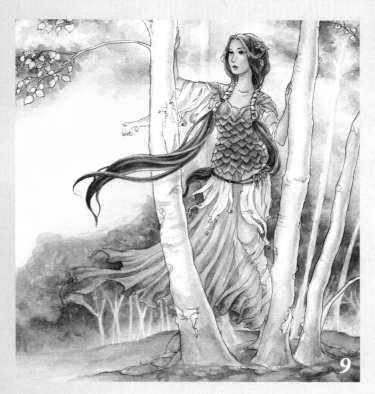

paint colors vary, since they are all being added to generally the same area, they will mix together.

Add shadows to the birch bark on her dress and sleeves with pale Sap Green and Yellow Ochre. Add a little Cerulean Blue for the upper sleeves and leaves on her belt. Then glaze Payne's Gray over the birch bark pieces.

Shade the leaf shapes on her bodice with Yellow Ochre and Burnt Sienna. Outline the edges with Sap Green mixed with Cerulean Blue, then Burnt Sienna again.

10 *Create the Bark Texture*
Drybrush the bark texture on the tree trunks with Payne's Gray. Follow the rounded contour of the trunk. Paint Burnt Sienna where the bark has peeled back. Paint Yellow Ochre over the close-up leaves in the treetops.

11 *Darken Bark Texture and Add Highlights*
Drybrush darker Payne's Gray over the bark on the trees and her dress. Then use White Gouache to add highlights to her eyes and sections of her bodice.

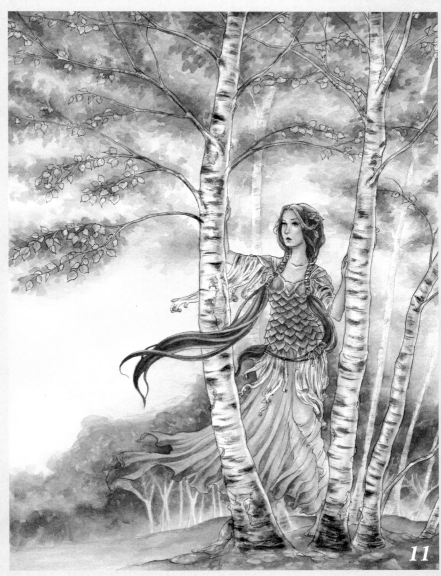

Water

WATER CAN TAKE ON NEARLY ANY SHAPE AND MOOD imaginable. It may be silent and calm, or gently ripple and roll. But it can also relentlessly crash or pound, an unstoppable force carving the landscape to its whim. Learning to paint water is instrumental for painting mermaids, undines and water fae, as well as a variety of background scenes.

Painting Calm Surface Water

1 Paint a flat wash of Phthalo Blue.

2 While the base color is still wet, paint a pattern of shadows with Cobalt Blue.

3 After the last layer has dried, darken some of the shadows with Cerulean Blue.

Shallow Waves

1 To create a wave, paint the base color in pale Phthalo Blue. Leave whitecaps at the peak.

2 Glaze another layer of Phthalo Blue, leaving a few more highlights.

3 Mix Cerulean Blue and Cobalt Blue to add more shadows.

Breaking Waves

1 Paint the base color with light Phthalo Blue. Leave the top of the wave white and paint around the jagged curled edge. Use masking on this part if you need to.

2 Use Cerulean Blue to add shadows to the wave along the top edge and bands curving inward. Blend the color toward the bottom. Darken the space between the tendrils on the wave tip.

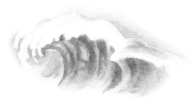

3 Add more shadows within the darker bands with Cerulean Blue. Build up the darkest shadows with Cobalt Blue.

Pearls

MERMAIDS ADORN THEMSELVES with strands of pearls, shells and wave–worn sea glass. A world of iridescent colors and sparkling highlights can be found inside the chalky, durable exterior of a seashell. Create a single pearl, then use the same technique used for an individual pearl to paint a string of several.

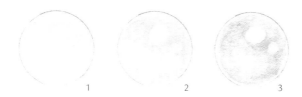

1 2 3

Painting a Pearl

1. Draw a circle. Mix Cadmium Yellow and Quinacridone Red and dilute with water to paint a very light coat over the top edge. Leave some white for highlights around the edge and blend the color toward the bottom.
2. Glaze very light shadows with a pale (diluted) Quinacridone Red over the outer edges.
3. Use a dry-brush technique to add hints of Phthalo Blue and Quinacridone Red separately. Then mix the colors together to drybrush some darker areas.

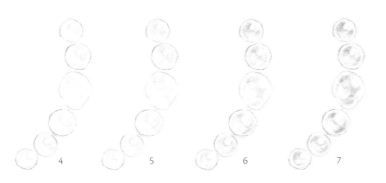

4 5 6 7

4. Paint Cadmium Yellow mixed with a little Quinacridone Red around the highlights. Keep the color lightest toward the center.
5. Next, glaze very light Quinacridone Red over each pearl on the darkest areas of yellow.
6. Drybrush a glaze of Phthalo Blue around the edges.
7. Mix Phthalo Blue and Quinacridone Red and drybrush to build up the darkest spots.

A pearl can display the same rainbow colors of the shell it came from or be more subtle. The most-prized ocean pearls are round and white, although other colors exist. Freshwater pearls come in many irregular shapes. Use many glazes to create a spherical shape, but make sure some of each pure color and shape shows through.

From a Drop to a Splash

Water drops are fun to paint and are always a part of a mermaid's surroundings.

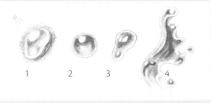

1 2 3 4

1. Pay attention to the direction of the light sources and place the highlight where it shines. Around the highlight are both a shadow and reflected light that shows through on the other side.
2. Begin with a simple rounded drop.
3. When the drop is elongated, the highlights and reflections are stretched out as well. Experiment with drawing different shapes.
4. Painting a splash is easier than it looks. The splash is just a collection of many different-shaped water drops all stretched out and stuck together.

Mermaid Tails and Fins

WATER SPIRITS HAVE CAPTIVATED THE WORLD for thousands of years. Stories of half-human, half-fish creatures who live underwater in oceans and streams abound in many cultures, with mermaids being the most well known.

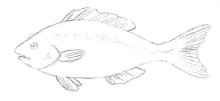

Fins
Studying where the fins commonly attach on a fish can help you to decide where to place them on a mermaid. Even though a mermaid's tail starts at the waist, you can add fins to the upper body to draw it all together.

Drawing Fins
While there are many variations, most fins and flippers follow a similar shape. What do you want to portray: sharp and spiky or soft and flowing? Traditionally, mermaid tails have been portrayed flipper-like to most resemble feet. Don't hesitate to consult educational videos to see underwater creatures in motion.

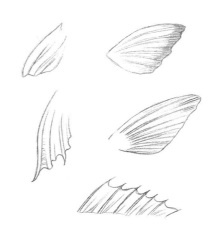

Scales
Start with a line of scalloped shapes along the width of the tail. Draw the next line slightly offset from the first. Shade the center where the next row of scales overlaps. Be sure to draw rows of scales following the curve of the body rather than a straight line.

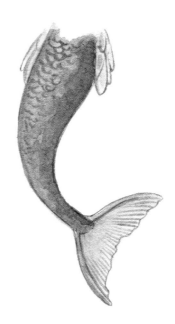

1 Paint Viridian over the tail, making it darker toward the edges. Paint pale Viridian over the tail fin.

2 Dot Cerulean Blue along the edges and over most of the right side.

3 Mix Viridian and Cerulean Blue and paint small rounded scales across the lighter part of the tail. Paint thin lines across the tail fin.

PAINT A WATER SPIRIT

SIREN'S SONG

As THE GOLDEN LIGHT OF DAWN touches the world, a siren plays a melody to the swirling gulls. Formed of water and mother of pearl, her dress flows like water back into the sea from where she has come.

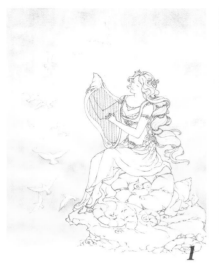 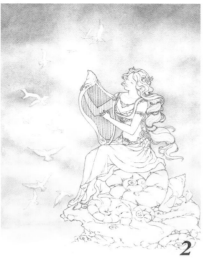 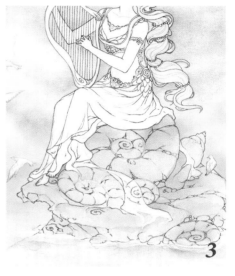

MATERIALS

assorted brushes

hot-pressed watercolor paper

pen, pencil and waterproof ink

PAINTS

Brown Madder

Burnt Sienna

Cadmium Yellow

Cerulean Blue

Cobalt Blue

Dioxazine Purple

Payne's Gray

Phthalocyanine Blue

Quinacridone Red

Quinacridone Violet

Raw Sienna

Raw Umber

Sepia

Viridian

White Gouache

1 Paint the Dawn Skies

Paint light Raw Sienna over much of the picture including the rocks. Switch to smaller brushes to paint around tighter edges. Paint this area from top to bottom, lighter to more concentrated. Fill in the siren's hair with a light Raw Sienna as well.

When dry, paint a light Cerulean Blue over the top part of the image, leaving white space for clouds and avoiding the birds.

2 Deepen the Skies

Paint more Cerulean Blue over the top, around the siren and inside the harp. Paint around the small corners and birds, then blend out the edges. Bring some of the blue sky down into the yellow. Darken some of the Raw Sienna around the bottom.

3 Glaze the Rocky Outcrop

Glaze light Raw Sienna and light Quinacridone Red over the shell shapes on the right and the rocks near her feet, one at a time. When the rocks are dry, glaze Quinacridone Violet over some of the rocks near the center, leaving lighter color around the outer edges. Mix a diluted Cobalt Blue and Dioxazine Purple, and paint around the upper edge of the rocks under the siren's skirt. Blend the color out toward the bottom.

Glaze a pale Cerulean Blue over the right side of the upper sky to make some of the clouds recede. Then do the same over the central area with pale Raw Sienna and Quinacridone Red toward the horizon. Darken some of the areas between the clouds with the same colors. Paint the distant islands with light Quinacridone Violet. Paint the water with light Cerulean Blue along the bottom edge of the rocks, leaving some white space between. Paint faint rocks showing through the water with Quinacridone Violet.

4 Shade the Rocks

Begin shading stone with varying mixes of Cobalt Blue and Dioxazine Purple, adding in Payne's Gray for darker areas. Paint Quinacridone Violet plus a little Cobalt Blue along the pinker edges of the outcrop. Glaze some Raw Sienna over the shell on its right-side edges and the left edges of the rocks. Shade the center of the right-side shell with light Quinacridone Violet, and then darken the distant islands.

Deepen the color of the water with Cerulean Blue.

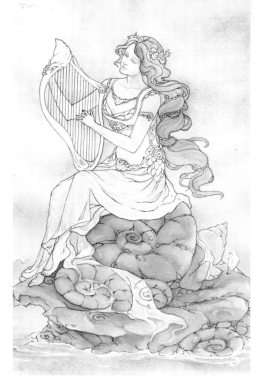

5 Begin the Figure

Indicate the shadows on the siren's skin with Dioxazine Purple, adding a little Cobalt Blue for deeper shadows. Begin painting her skirt with very light Phthalo Blue, leaving white highlights to resemble flowing water. Fill in her hair with Raw Sienna around the edges and add Burnt Sienna in the center while wet.

6 Glaze the Skin and Darken the Skirt

Glaze her skin with Raw Sienna, painting darker over the purple shadows. Paint her hair with a layer of Burnt Sienna. Continue building up the skirt color with Phthalo Blue. Paint a touch of it on the top of her bodice.

Make a pale mix of Cadmium Yellow and a touch of Quinacridone Red, then begin shading her bodice and the pearly shells in her hair and on the harp. Paint very lightly and leave plenty of white highlights. Paint the gold trim and harp with Raw Sienna again, leaving plenty of white spots.

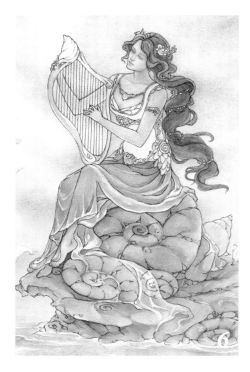

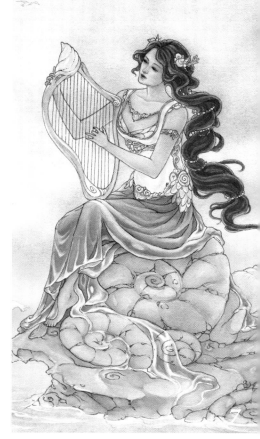

7 Finish Her Skin

Glaze the siren's skin with Brown Madder. Then glaze Quinacridone Red over some areas like elbows, wrists, shoulders and cheeks. Outline her eyes with extra Brown Madder, then paint them with Raw Umber and Payne's Gray. Deepen her hair color with Burnt Sienna.

Glaze the pearly areas on her bodice and shells with pale Quinacridone Red, but allow some of the previous yellow to show. Paint the center stone in her necklace with light Cobalt Blue. Darken parts of the gold trim and harp with more Raw Sienna.

Mix Phthalo Blue plus Cobalt Blue to glaze the top of her skirt, then darken the wrinkles and the water flowing down the rocks. Glaze a touch of the blue mix over the center top of her bodice.

For more lessons using natural elements, go to impact-books.com/fairy-fantasy.

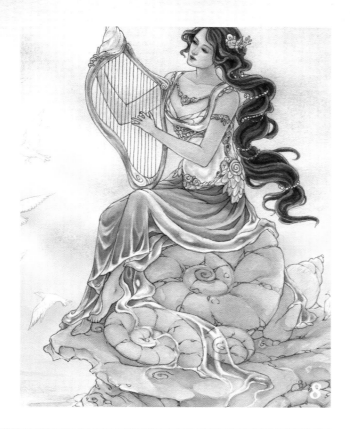

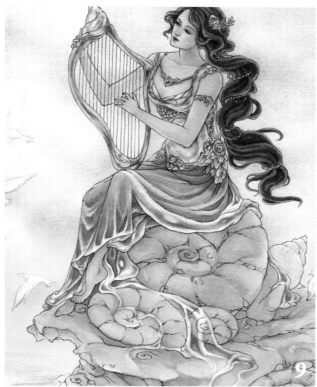

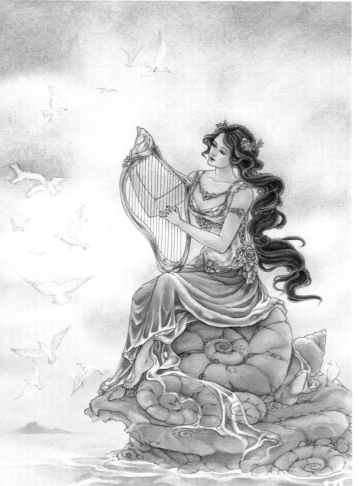

8 Glaze the Dress Colors

Continue to build the colors on the pearly areas with Phthalo Blue. Make sure some of the previous colors show through. Darken the center pendant with Cobalt Blue.

Create some deeper shadows on the harp and gold trim with Burnt Sienna plus Raw Sienna. Then glaze light Cadmium Yellow over the lighter spots. Pick out some deeper shadows between strands in her hair with Burnt Sienna plus Sepia.

Deepen some of the folds in her skirt with Cobalt Blue and Dioxazine Purple.

9 Continue Glazing

Alternately glaze Quinacridone Red and a mix of Quinacridone Red and Phthalo Blue over the pearly parts of her bodice, harp and hair. When dry, glaze some very pale Cadmium Yellow and Viridian separately over some of the lighter spots. Outline the pattern on the top of her bodice with Cobalt Blue. Finally, glaze a little Dioxazine Purple over some of the darker shadows on the harp.

10 Shade the Birds and the Stones

Shade the birds by bringing in some of the background colors like Raw Sienna and Cerulean Blue. Paint the tips of their wings with Cerulean Blue.

Shade the central parts of the rocky outcrop with Payne's Gray plus a little Dioxazine Purple and Cobalt Blue. Shade the outer edges and rocks showing through the water with Quinacridone Violet plus Cobalt Blue. Then glaze Quinacridone Violet over the right edge of the rocks.

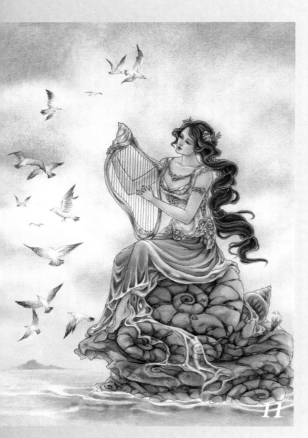

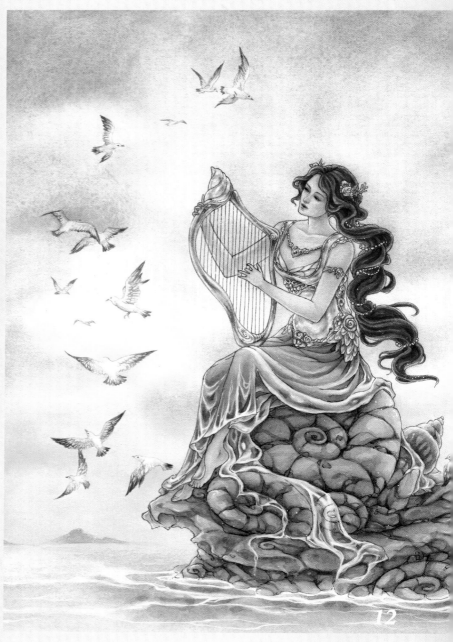

11 Detail the Stones and the Birds

Add another layer of shading to the stone with mixes of Payne's Gray, Cobalt Blue and Dioxazine Purple, then add small cracks. Add deeper shadows to some of the stone that's underwater, then the lower edges and trailing bits of her skirt where it overlaps. Darken the ocean water at the bottom with light Cerulean Blue.

Paint the birds' wing tips with Payne's Gray, painting lighter toward the center. Shade the bodies with pale Payne's Gray.

Add more shadows on her skin with Brown Madder.

12 Add Highlights

Use White Gouache to add small highlights to the pearls and pearlescent areas of her dress, jewelry and harp. Add a few lighter feathers on the wings with White Gouache. Paint a few more lines and highlights on the lighter parts of her skirt to create a watery pattern. Paint some small drops to the right of her feet. Then add the white pattern on the surface of the water below.

Finally, spatter some white mist over the background by tapping the brush handle, but avoid spattering the figure.

The Moon and Clouds

WHEN THE MOON IS FULL and wispy clouds hover nearby, the edges catch the moonlight and create a dramatic, bright outline.

MATERIALS

assorted brushes

hot-pressed watercolor paper

pencil

PAINTS

Cerulean Blue

Dioxazine Purple

Payne's Gray

White Gouache

1 Start With the Base Color
Lightly sketch a circle for the moon. Mix Cerulean Blue and a little Dioxazine Purple, then lay down the background color, beginning with the outline of the moon. Drop in more color while still wet to create the cloud texture.

2 Create Contrast
Use Cerulean Blue plus a little Dioxazine Purple to paint the edges of the cloud forms. Immediately blend inward while still wet and leave a lighter circle around the moon.

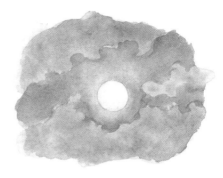

3 Create Cloud Shadows
Wet the clouds and drop in a mix of Cerulean Blue and Payne's Gray to darken parts of the background. Add a tiny bit of Dioxazine Purple in the areas where the clouds meet the background.

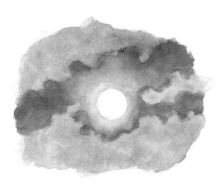

4 Deepen the Sky
Paint between the clouds with a Cerulean Blue plus Payne's Gray. Darken along the edges, then soften with clean water.

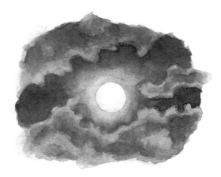

5 Build up Cloud Shadows
Add shadows in the clouds, then blend the edges to make sure they are soft. Leave wispy light areas. Darken the edges of the sky with Payne's Gray and some Cerulean Blue. Blend the edges.

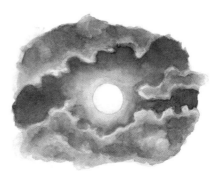

6 Add White Highlights
Using White Gouache, add highlights along the edges of the clouds closest to the moon. Use the white to paint inside the edges of the moon.

The Stars

SPARKLING STARS are what makes the night sky so magical. There is more than one good way to paint stars, so you can pick the technique you like best. Stars come in a variety of colors and brightnesses and can flow together as galaxies or the arc of the Milky Way.

MATERIALS

assorted brushes

assorted watercolors

masking fluid

watercolor paper

Use Masking Fluid

1. Spatter the masking fluid by tapping the top of your brush over the paper, then paint your sky color over the dry masking. (Because the masking is heavier than water, spattering will create larger spots than dotting individual spots on the paper.)
2. Remove the masking when the paint is completely dry. Use an old brush or vinyl-tip brush.

Use White Gouache

1. Paint your desired background sky color.
2. Then use White Gouache spatter or white paint for stars. Keep the paint opaque by using as little water as needed to make the paint spatter. Use a very small brush for dotting the individual stars. The advantage of spattering is that it creates a more organic feel, avoiding the natural tendency to paint a symmetrical pattern of stars.

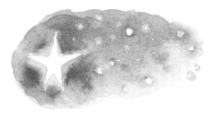

Create Glowing Stars

To create a glow around stars, you can paint successively darker glazes around a white shape, leaving the lighter areas closest to the star. Or lift up darker paint around your star with a wet brush.

Light Sources

Your light source is important, especially for night scenes with glowing lights. Notice how the sphere directly in front of the light is mostly in shadow. Photographers refer to the hour before sunset as *magic hour*, where edge lighting and rich, warm color variances help bring many ordinary subjects to life. Light also bounces off objects when they are lit, making them into mild, colored light sources for things nearby. All of these effects can be used to add warmth and detail to your subjects.

Edge Lighting

The warm lighting just before sunset, when the sun is low in the sky, lights up the edges of the subject with a golden glow.

THE STAR BEARER

A CELESTIAL MAIDEN dances through the night sky, bearing a starlight lamp. Her clothing is inspired by belly–dance costumes, while star and moon shapes adorn her hair and bodice. The sections of her belt show the phases of the moon.

The limited color palette of blues and violets makes a tranquil scene and allows the golden light to stand out in the composition.

MATERIALS

assorted brushes

hot-pressed watercolor paper

pen, pencil and water-proof ink

PAINTS

Cadmium Red

Cadmium Yellow

Cerulean Blue

Cobalt Blue

Dioxazine Purple

Lamp Black

Payne's Gray

White Gouache

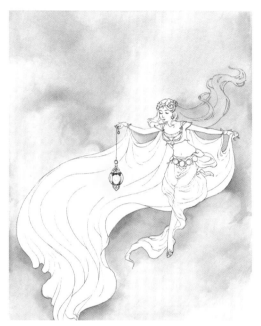

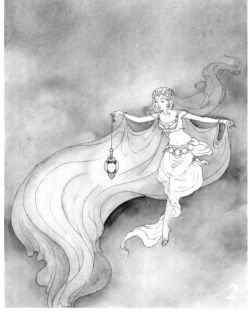

1 Lay Down the Background Wash
Paint around the figure with light Dioxazine Purple. Create cloud shapes by painting the edge of the cloud and softening the edge with water. Keep the area you are painting wet to allow the paint to flow randomly and form the misty cloud effect. Darken the areas between the clouds. Using Cadmium Yellow, paint a light circle around the lamp and then blend the edges out.

2 Glaze the Background
Paint very pale Cadmium Yellow around the lamp to indicate reflected light on her veil. Paint Cerulean Blue over her veil, but leave a glow around the lamp. Blend the edges closest to the lamplight.

Painting wet-in-wet, add a light Cerulean Blue over the background, using the deepest color in the shadows. Mix Payne's Gray and Cobalt Blue, then darken the shadows between the clouds.

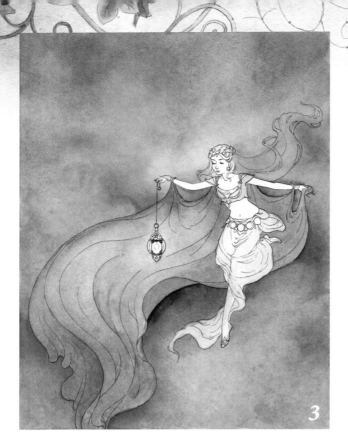

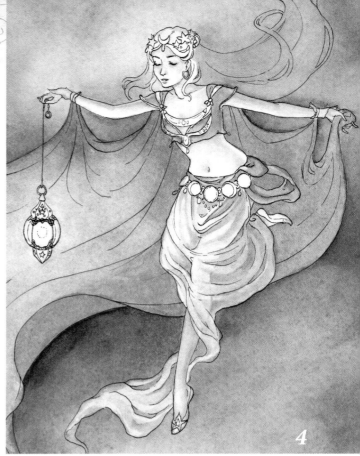

3 Deepen the Background and Cloak Color

Paint Cerulean Blue over most of the background wet-in-wet, allowing paint to flow organically. Deepen the shadows in the clouds. Deepen the Cerulean Blue on the cloak. Paint very pale Cerulean Blue over her skirt and light Dioxazine Purple on her top.

4 Create Shadows on the Skin and Clothing

Paint shadows on the figure's skin using Dioxazine Purple and Cobalt Blue. Use deeper color away from the lamplight. Leave a sliver of space on her far side to indicate backlighting.

Add shadows to her skirt using light Dioxazine Purple. Use a second layer for shadows on the deepest folds.

5 Finish the Skin and Begin the Hair

Glaze a very pale mix of Cadmium Yellow and Cadmium Red over all of her skin. Use less water to deepen the color in the shadows and allow to dry. Paint over the darkest shadows with a very light Cadmium Red. Paint the base layer of her hair with a mix of Cobalt Blue and Payne's Gray.

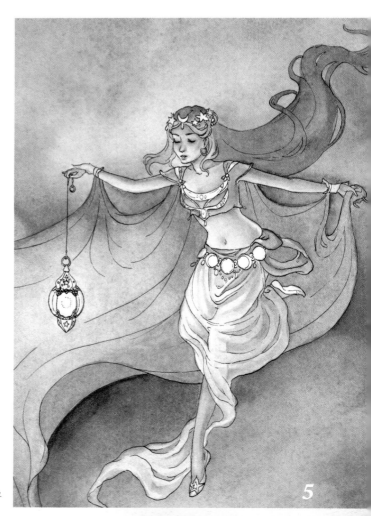

Sky Blues

When mixing the colors for the sky, you will end up with a lot of variations of the mixes in your palette. Use these wherever you feel they fit or for shadows. Don't worry about the exact colors as much as the values.

For more lessons using natural elements, go to impact-books.com/fairy-fantasy.

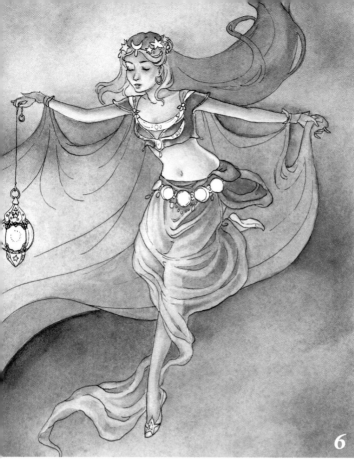

6

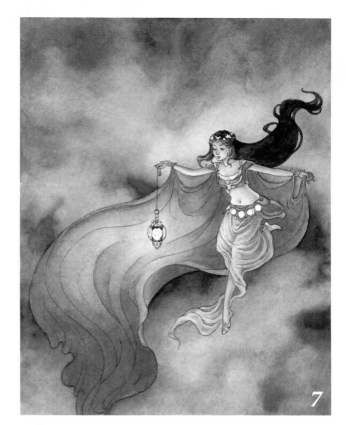

7

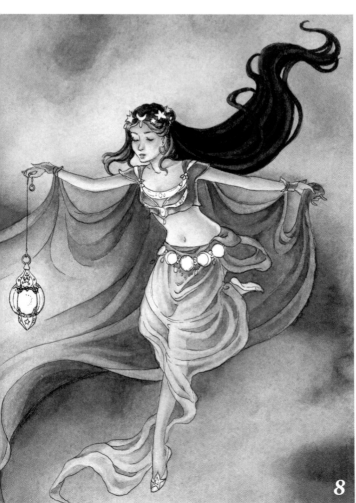

8

6 Deepen the Skirt Color
Glaze a light layer of Cerulean Blue over the skirt, darkest away from the light, then deepen the shadows in the folds.

7 Build the Darker Values on the Sky and Cloak
Glaze a mix of Cobalt Blue and Dioxazine Purple over the bottom and top of the cloak, leaving it lighter in the center around the lamp.

Using the same color, pick out irregular shapes in the clouds and darken the areas between. Then glaze another layer of Cobalt Blue and Payne's Gray over her hair.

8 Create Deeper Shadows
Darken the shadows on her skirt with Payne's Gray and Cobalt Blue. Glaze over the top and bottom ends with the same color and add a little Dioxazine Purple in some spots. Then deepen the shadows in the folds.

Building up Layers

If you want a dark background but have a hard time placing the final layers of paint, try using a dry-brush technique to slowly build up the darkest values without disturbing the existing color.

9

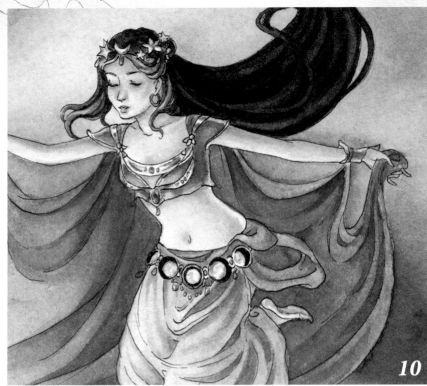

10

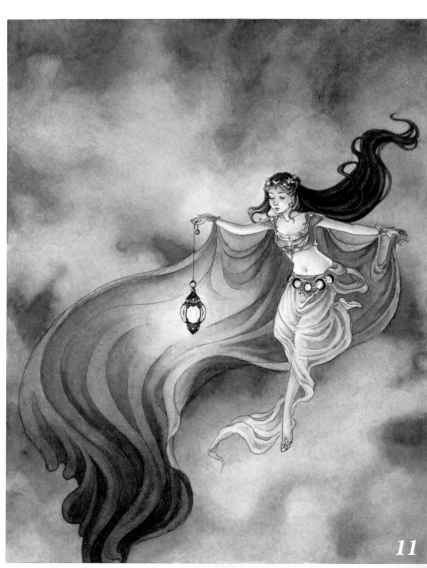

11

9 *Glaze Black Over the Deepest Folds*
Darken the deepest folds in the bottom of the cloak with a Lamp Black glaze.

10 *Add Detail to the Jewelry*
Use a light mix of Cerulean Blue and Payne's Gray to indicate the shadows on the silver jewelry and belt. Dab small spots in the round sections of the belt to mimic the texture of the moon, and then paint Payne's Gray on each to represent the night sky. Paint the lamp with Payne's Gray as well, using a deeper color at the top and bottom.

11 *Balance the Composition*
Add balance to the composition by darkening the sky in the top right corner. Glaze Cerulean Blue, then a mix of Cerulean Blue, Cobalt Blue and Payne's Gray over the darkest areas.
 This step could have been done earlier, but sometimes a painting doesn't come together in the correct order.

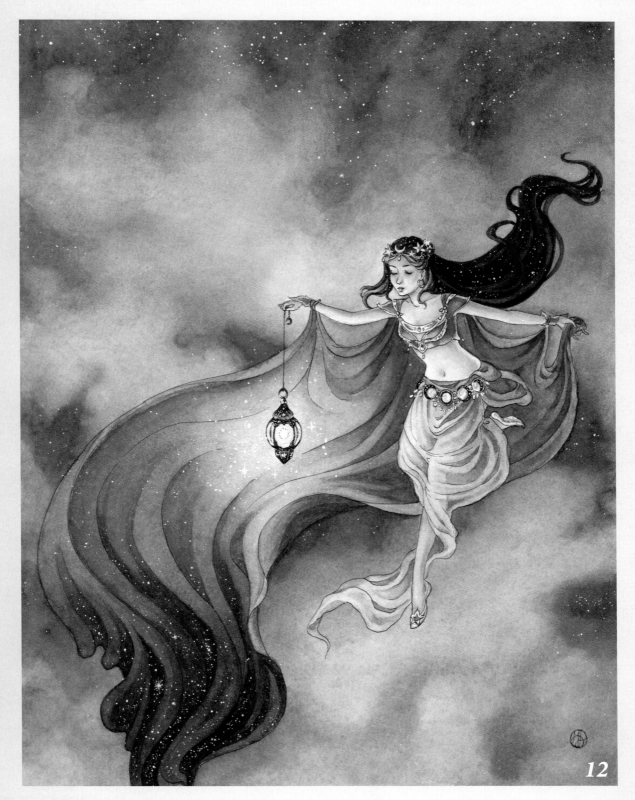

12

12 *Add the Stars*
Spatter White Gouache around the lamp, the bottom of the cloak and over the sky at the top of the painting. Use a no. 0 or smaller brush to dot white stars in her hair and in the darkest folds of the cloak. Add more around the lamp and as a highlight on the jewelry and belt.

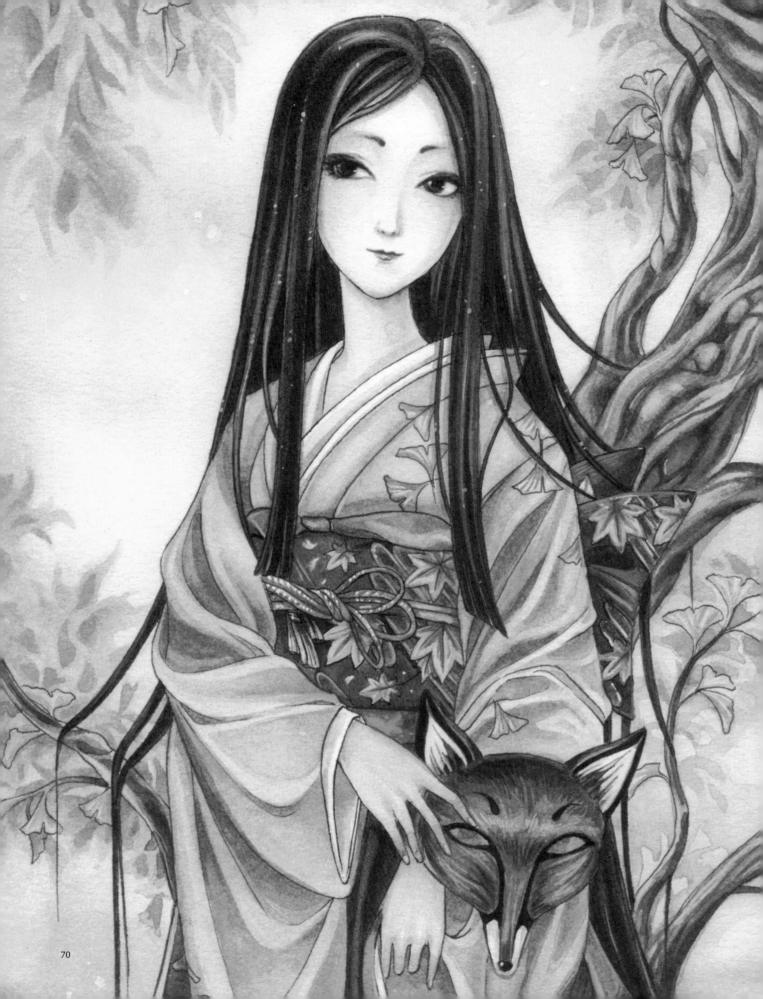

Myths and Legends

HUMANS HAVE ALWAYS USED STORIES to explain the world. A wealth of folklore, myths and legends has been passed down through the ages. Many of these stories are familiar to us through modern authors and filmmakers who have been inspired by ancient tales. Overlapping mythical themes show up in cultures throughout the world. With a little research you can draw inspiration from a suitable time and place to create your own unique interpretation.

Medieval Fashions

MEDIEVAL STYLES CALL TO MIND LEGENDS of King Arthur and the Knights of the Round Table, fairy tales and nineteenth-century Pre-Raphaelite paintings. Pre-Raphaelite interpretations may not be completely accurate in the details, but often have the correct shapes.

Women's dresses were low-necked and one piece, fitted to the hips where they dropped into a flowing full skirt. Medieval clothing was worn in multiple layers, often with contrasting colors. Both men and women wore white undergarments to protect their outer layers, which were made of finer cloth. Outer layers were decorated with embroidered borders, often wide at the trailing edge of skirts. Women's dresses were often so long they needed to be lifted to walk, which showed off the contrasting color underneath.

The earliest Western clothing were simple loose tunics belted at the waist. Most garments were made with rectangular pieces of fabric, but gradually became more fitted.

Once you get the basic shapes down, change the details to your liking. Avoid a Renaissance Faire look by drawing dresses in one piece. Separate bodices with contrasting fronts weren't in fashion until the 1600s. Short skirts and off-the-shoulder blouses look out of place.

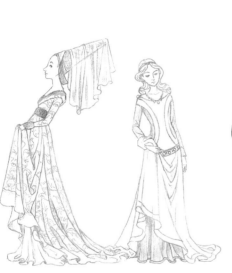

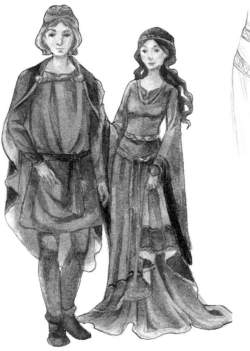

Belts

A belt, or girdle, worn at the hip creates the impression of a long waist. Girdles can be made as embroidered fabric, braided cord or metal links. Experiment with different shaped links.

Dresses

A mid-fifteenth-century Burgundian lady wears a high-waisted V-neck dress with a large fur-lined collar. Her belt is wide, and her overdress is made of rich brocaded fabric. She wears a pointed hat and veil. She stands in a swooped posture typical of paintings from the period.

A sleeveless dress called a sideless surcoat with large openings on the sides was worn over another dress with long fitted sleeves. This style was popular through the fourteenth and fifteenth centuries.

Medieval Couple

The man wears a shorter tunic over tights with a cloak held up by metal clasps and a chain. The woman is wearing a tunic dress called a *bliaut*, which is tightened with laces at the side. The edges and upper arms are trimmed with embroidery.

The Hennin

The conical hat often worn by princesses in fairy tale illustrations was known as a *hennin* and came in many variations from short and truncated to an extremely long cone. The hat was then dressed with a veil in a variety of styles.

Inspiration from Medieval Arts

A TREASURE TROVE OF INSPIRATION can be found in the arts and architecture of the medieval world. Creative energy was poured into the construction of massive cathedrals, all decorated with sculpture, paintings and stained-glass windows. Books were hand-lettered and illustrated so ornately they are called illuminated manuscripts. These illustrations are great sources of reference for historical clothing, as well as decorative motifs.

Architectural Motifs

The most prevalent architectural motif in the medieval era is a clover shape called a trefoil, which was used in windows, arches and combined with scrolling manuscript borders. Sometimes the three sides become pointy like a maple leaf. Tear shapes combined with trefoils often make up window designs.

Step-by-Step Leaf Scroll

1. Sketch a wavy S-shaped ribbon.
2. Sketch the leaf-shaped edges along the ribbon, changing direction in the center.
3. Color the top side green and back side pink or use other contrasting colors.

Wildflowers

Wildflowers or twisting scrolls of leaves and blossoms showed up in manuscript illustrations as borders. Each flower usually had symbolic meaning. Thistles, strawberries, pansies, forget-me-nots, periwinkles and carnations were common.

Acanthus Leaves

Acanthus leaves, used in architecture and decorative art since the ancient Greeks, were commonly used as a border or even covered entire pages of repeating scrolls. They were commonly depicted as twisting ribbons of leaves, with each side being a different color.

Rose and Pomegranate

Depicted both naturally and stylized, roses and pomegranate fruits were highly symbolic. Pomegranates were symbolic of temptation and later fertility in Christian art. They were often depicted on tapestry behind the Virgin Mary and in unicorn tapestries. Roses were identified with love, devotion and Christian martyrs.

ENCHANTED FOREST

A MEDIEVAL PRINCESS meets a unicorn in an enchanted forest. Her emerald-green dress mimics the colors of the woods and the wild roses along the path.

In medieval legends, only a pure maiden was able to tame a unicorn. Roses were a common art motif used in the medieval world, symbolizing both love and religious devotion.

MATERIALS

assorted brushes

hot-pressed watercolor paper

pen, pencil and water-proof ink

PAINTS

Alizarin Crimson

Brown Madder

Burnt Sienna

Cadmium Red

Cadmium Yellow

Cobalt Blue

Dioxazine Purple

Hooker's Green

Payne's Gray

Raw Sienna

Raw Umber

Sap Green

Sepia

Viridian

White Gouache

Yellow Ochre

1 Create the Misty Background

Paint light Viridian around the edges of the background down to the base of the trees. Blend inward with clean water. Then paint light Sap Green over most of the background, lighter toward the center. Avoid painting the maiden and unicorn.

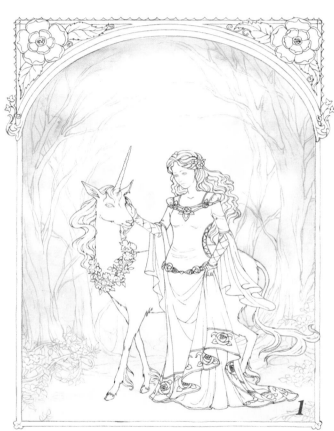

Unicorn

Unicorn Head

Your unicorn's head can be based on a variety of animals, not just a horse. The horse's head is larger and muscular, while a deer or antelope is more graceful.

Draw the Horn

Sketch a cone shape, then sketch diagonal lines across it. Think of a thin ribbon spiraling around the cone.

For more lessons incorporating myths and legends, go to impact-books.com/fairy-fantasy.

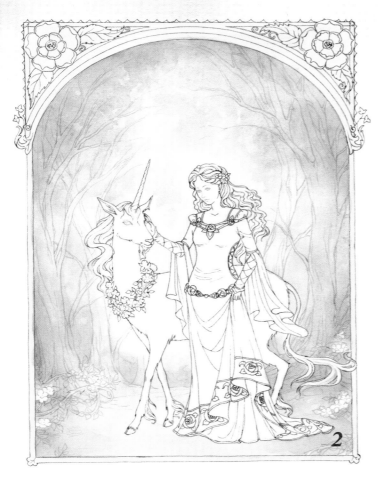

2 Glaze the Background and Begin the Border

Mix Viridian and Sap Green to paint along the base of the trees. Dot some color in between the thorns and roses at the corners. While wet, drop in a little Yellow Ochre. Use clean water to blend it all together. Then mix Yellow Ochre with the green mix and paint lightly over the rest of the ground.

Create a base for the upper foliage using Viridian to paint around the top arch. Apply using dots and a scribbling motion. Use clean water to blend the spots together. Paint the lower foliage with the same technique using Viridian plus Sap Green. When dry, paint another layer of Viridian around the top edge.

Paint a light base coat of Yellow Ochre over the border. Paint the smaller edges.

3 Paint the Trees and Roses

Build up the color of the border using a no. 2 brush and light Yellow Ochre.

Fill in the negative spaces between the rose branches with a mix of Viridian and Dioxazine Purple using a no. 2 brush. Paint around the outer leaves letting the color fade toward the center.

Using a no. 4 brush, paint light Viridian over the trees. Mix in a little Sap Green for the trees farthest away. Then use the Viridian and purple mixture to paint shadows on the trees by painting the base of the trunks darker and then a lighter wide shadow in the center. Paint vertical lines to suggest bark. Fill in some of the branches as well. Then glaze the ground with very light Sap Green.

Use a dabbing motion to paint a layer of foliage at the top. Dab varying strengths of Viridian and Viridian mixed with Sap Green. Then soften the edges and blend some of the paint splotches together with clean water. Add some shades of the Viridian and purple mixture near the top edges.

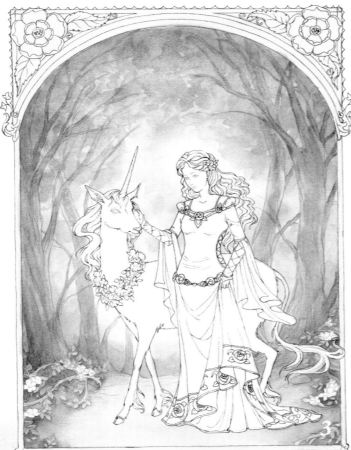

4 Shade the Trees and Ground

Darken the negative spaces around the leaves and roses at the bottom with a mix of Sap Green and Raw Umber. Paint faint shadows on the rose petals. Use the same color to paint the rocky texture on the ground, leaving spaces for an uneven rocky appearance. Then glaze this color on some of the upper foliage and along the fronts of the tree trunks.

Use Yellow Ochre to paint the border. Shade the center of the thin borders, leaving lighter color along the edges.

5 Add Details to the Background

Use light Cadmium Red to paint several layers on the roses. Paint a light (diluted) base color and add shading with another layer of pure Cadmium Red.

Glaze light Sap Green over some of the rose leaves and Raw Umber over the stems. Add more shading between the leaves and increase the bark texture with a mix of Viridian and purple. Paint shadows on the rocks under the unicorn's hooves and around the base of the maiden's dress.

Create the upper foliage by painting leaf shapes and filling in the negative areas around them with mixes of Viridian and Dioxazine Purple and Viridian and Sap Green.

Shade the border with Yellow Ochre between the recessed areas and around the rose petals. Glaze Cadmium Red and Sap Green over the scrolling leaves on each side.

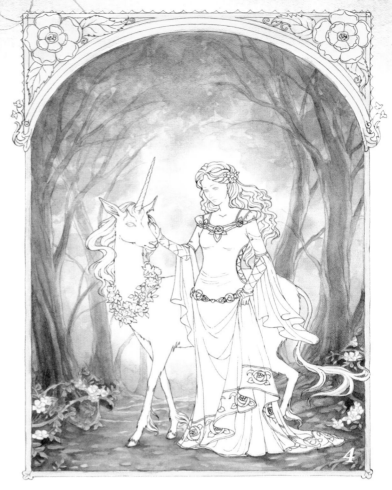

4

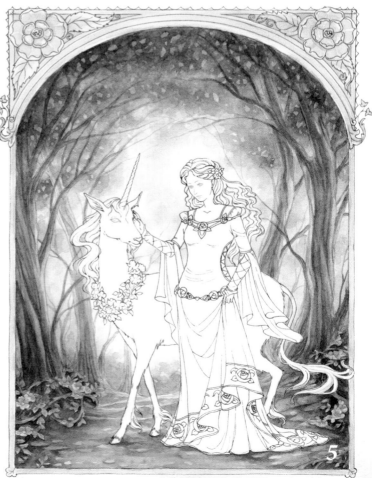

5

Place the Legs

If you aren't used to drawing four-legged creatures, sketch a simple grid to aid in placing the legs in perspective.

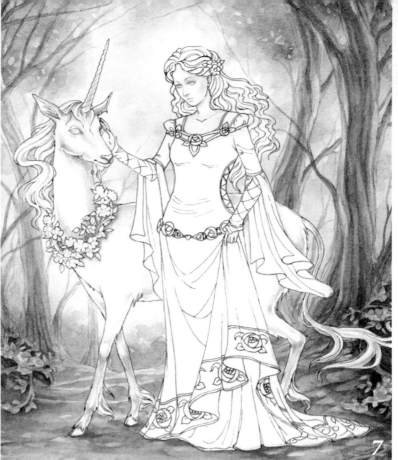

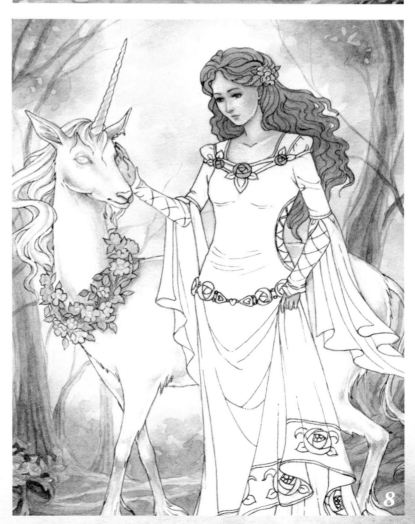

6 Finish the Border

Continue shading with Yellow Ochre and Burnt Sienna. Fill in the recesses and shade the center of the leaves. Blend toward the edges of the leaves. For each of the large petals, leave a ridge along the center unpainted and shade the sides. Paint the darkest color along the corners of the border and blend down. Do the same with the center and side of the arch. Shade the center, leaving some lighter color on the edges. Use Burnt Sienna and Raw Umber for the darkest shadows under the roses on the border.

7 Place Shadows on Her Skin

Add shadows to her skin with Dioxazine Purple. Use Viridian and purple to make the shadows on the unicorn. Make it darker between the leaves in the garland around its neck.

8 Finish Her Skin

Glaze Raw Sienna over the skin, leaving lots of white highlights. Paint mostly over previously painted shadows. Fill in her hair with Burnt Sienna mixed with Raw Umber.

Glaze Brown Madder over her skin and lips. Paint a little darker around the eyes. When dry, paint her eyes with Payne's Gray and Sap Green. Use Burnt Sienna plus Raw Umber on the eyebrows and add a touch of Cadmium Red to her lips. Paint the flowers in her hair, garland and collar using pale Cadmium Red. Use pale Sap Green for the leaves and Cadmium Yellow for the centers.

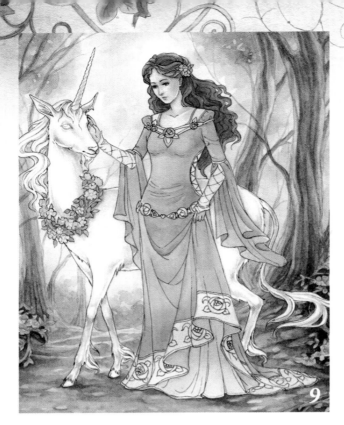

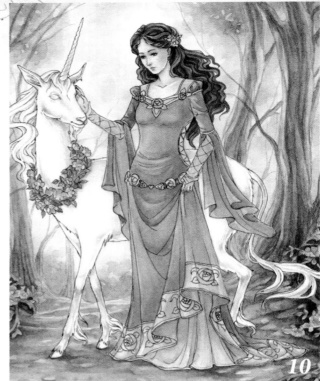

9 Paint the Dress

Paint the base tones of her dress with Sap Green for the main part, Cadmium Red for the lining and Yellow Ochre for the underdress and trim. When dry, glaze the top of the yellow skirt with Cadmium Red.

Add shadows to her hair with Burnt Sienna mixed with Raw Umber.

10 Deepen the Dress Color

Deepen the color on the main part of her dress with Viridian. Shade the insides of her sleeves and skirt with Alizarin Crimson.

Mix Yellow Ochre and Burnt Sienna on gold parts. Add deeper shadows to her hair with Burnt Sienna and Sepia.

Darken the leaves on the garland with Viridian plus Sap Green and Cadmium Red on the flowers.

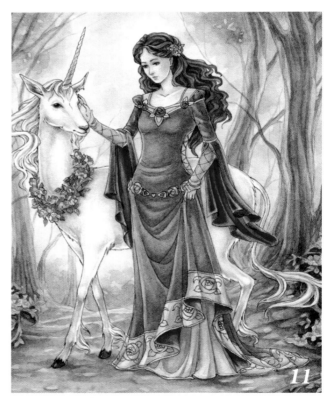

Hooves

Unicorns are said to have cloven goat hooves. Study the hooves of similar animals for reference. When viewed from the side, a deer's hoof is analogous to human fingers, with the closest joint being the wrist.

11 Add Shadows to the Dress

Mix Viridian plus Cobalt Blue to paint shadows on the dress using a no. 4 brush. Switch to no. 2 to paint shadows on the red parts with Alizarin Crimson plus Dioxazine Purple. Shade the roses on the garland and in her hair and collar with Alizarin Crimson as well. Shade the gold trim and underdress with more Yellow Ochre plus Burnt

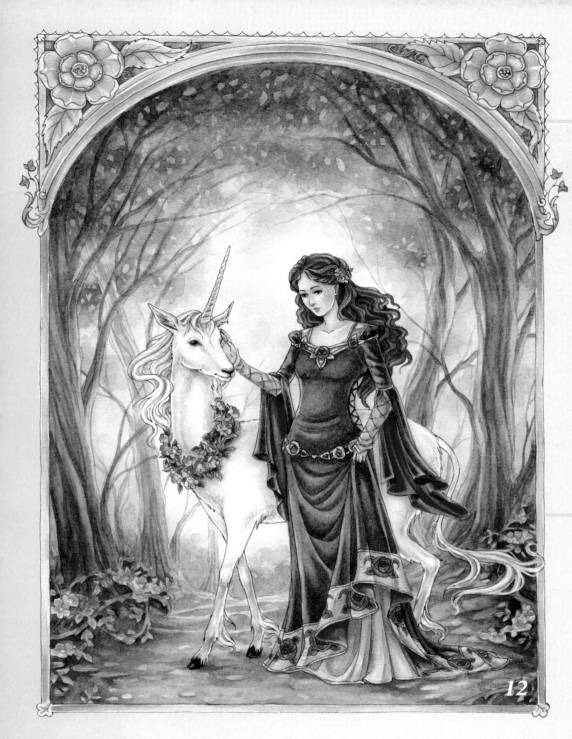

The unicorn was a popular figure in medieval folklore. Legends of the unicorn speak of a horned white horse with a goat's beard, cloven hooves and a lion's tail. A unicorn was considered to be wild and untamable except by a fair maiden. It was believed to hold many magical powers and the ability to heal. Many medieval depictions of the unicorn appear more like a goat than a horse. Look to animals like the gazelle, impala and deer to capture the graceful essence of a unicorn.

Sienna and a touch of Alizarin Crimson. Use a no. 1 brush to paint a little Alizarin Crimson in the hearts and flowers on her belt.

Deepen the shadows on the unicorn with light Raw Umber plus Payne's Gray and a little Viridian in varying amounts. Shade the neck, under the garland, and around the leg joints and hooves. Darken shadows on the horn. Paint the hooves eye and nose with Payne's Gray.

12 Add Final Details
Mix Yellow Ochre and Burnt Sienna to darken the shadows on the gold trim on the collar and sleeves. Add a touch of Alizarin Crimson in the hearts and roses on her collar and belt. Paint short,

thin strokes of gold across the bottom trim to suggest embroidery. Paint Cadmium Red and Sap Green lightly over the roses and leaves on the dress bottom. When dry, make short embroidery-like strokes with Alizarin Crimson and Hooker's Green over the petals and leaves. Outline the roses and paint circles in the centers with Alizarin Crimson. Add shadows to the leaves in her hair and garland with Hooker's Green. Use the Viridian/purple mix to darken the shadows on the green.

Finally, use White Gouache to add highlights on the unicorn's eye, horn and hair and also the maiden's belt and gold trim. Use small strokes to paint thread texture on the skirt trim.

Renaissance Fashions

IN THE RENAISSANCE a greater variety of fabrics and materials were available and it showed in the clothing. In fact, the word *fashion* came about in this era. Unlike the formal medieval fashions, garments were constructed in multiple pieces. Sleeves were often detachable and worn with many dresses. Stiffened undergarments and foundations for skirts came into use in some countries.

Sumptuary laws dictated how much money people could spend on clothing and what classes wore certain materials or colors. Lower classes were able to buy richer clothing secondhand. It became fashionable to slash the fabric in sleeves to show the contrasting color beneath because of decrees that commoners could wear only one color.

These images show different Renaissance sleeve detail variations of a particular style. Any of the variations can be combined or proportions altered for fantasy looks, unless you wish to illustrate a historical figure.

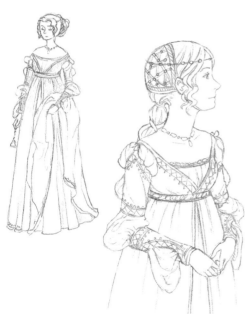

An English Tudor-style dress has a very stiff cone-shaped bodice made to keep fabric from creasing. It features a fuller skirt, often split in the center, worn over a large petticoat. Women wore jeweled girdles that hung down the center of this skirt, from which they often hung objects. It has a low, square neckline, with a jeweled trim matching belt. The large bell shaped sleeves were sometimes trimmed in fur. Inner sleeves were large and slashed with chemise peeking through the bottom.

An early Italian Renaissance dress circa 1500 features a high-waisted style with a split skirt over a chemise and very long sleeves bunched up and peaking through the sleeves.

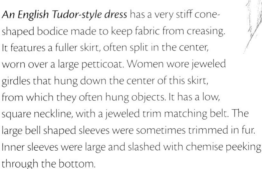

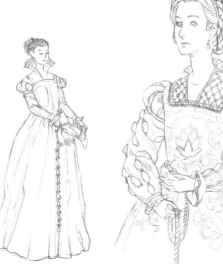

This Italian dress circa 1562 had two different types of sleeves. Sleeves became thicker and featured small slashes all along them or in vertical bands. The neckline is square with netting or lace over the shoulders. Materials were rich brocades with large motifs.

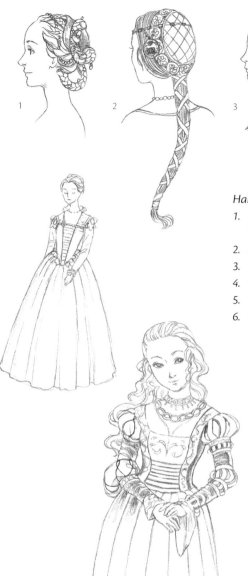

Hairstyles and Headdresses

1. Renaissance Italian hairstyle created with many twisting braids and curls entwined with strings of pearls and beads.
2. A small Juliet cap on the back with a long tail in a casing or wrapped in ribbon.
3. Wavy curls at the side with long hair twisted and tied in the back.
4. Combination of braids and loosely tied hair seen in Botticelli paintings.
5. Tudor-style French Hood with a jeweled front and a long black hood.
6. Hair pulled back under a German-style beaded net cap.

Fabric Motifs

Large scale fabric designs featuring a main stylized botanical motif surrounded by a symmetrical pattern twisting vines, leaves and florals were popular. Central motifs were often artichokes, pineapples and pomegranate, and thistles.

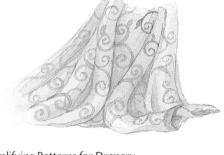

Simplifying Patterns for Drapery

Painting a pattern over an entire costume can become tedious to paint on drapery, so stick to painting complicated designs on a small area or edge. Twisting spirals are easier to paint than a large repeating pattern since you won't need to place them accurately. Imply a design by painting a suggestion of a pattern on the lighter areas of fabric and leaving the shadows.

Above is a German-style dress with banded stripes on the skirts and sleeves. Sleeves use slashed poofs with a matching color underneath. At other times the chemise shows through at elbows and shoulders with thin black ties. The bodice has an embroidered band under the bust and a section with thin laces. The fabric is likely velvet. Paintings by Hans Holbein provide reference for this style.

Swirling Vines

Interlocking bands of leaves and vines were painted alone or surrounding a central motif. Fabric in a famous portrait of Eleanora of Toledo by Bronzino shows a white background with a contrasting arabesque pattern in heightened black and gold.

FAIRY GRAIL

AS THE FADING LIGHT of dusk shines through the trees, the Fairy Queen carries a golden cup that shines from within with ancient power. Her dress, made of the finest fabrics available, is a fanciful fairy interpretation of the human fashions she remembers. Since time flows differently in the land of Fairy, its inhabitants often wear the fashions of ages past, carefully picking the parts they like and discarding the rest.

MATERIALS

assorted brushes

hot-pressed watercolor paper

pen, pencil and water-proof ink

PAINTS

Brown Madder

Burnt Sienna

Cadmium Red

Cadmium Yellow

Cerulean Blue

Dioxazine Purple

Payne's Gray

Permanent Alizarin Crimson

Phthalo Blue

Quinacridone Red

Quinacridone Violet

Raw Sienna

Raw Umber

Sepia

White Gouache

Yellow Ochre

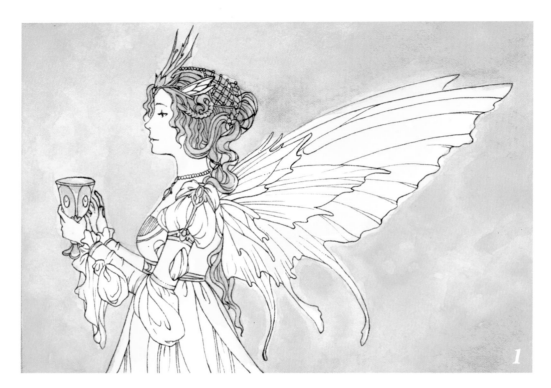

1 Lay Down the Background Washes

Using a no. 4 brush, paint a light layer of Yellow Ochre over the background. Dilute further to paint a pale yellow on the fairy's large wing and the reflections on her hands and the front and back of her dress.

Paint a second darker layer of Yellow Ochre over most of the background, allowing some lighter spots to show through. Then use a no. 2 brush to paint her hair, crown, goblet and the gold trim on the dress. Leave white for highlights on the goblet and gold trim.

2 Darken the Background and Paint Shadows on her Skin and Blouse

Using a no. 2 brush, paint pale shadows on the fairy's skin, blouse and white underskirt with Dioxazine Purple. Switch to a no. 0 for details, and shade her goblet, hair and gold trim with Raw Sienna. Then use Cadmium Yellow to paint sections in her small center wings.

Build up the background color with Raw Sienna, using a no. 4 brush. Paint around the edges, leaving lighter color around the figure and goblet. Create small circles of light by painting an outline and then blending the edges into the background with water. Finally, dilute the Raw Sienna and glaze a little over her dress and large wings.

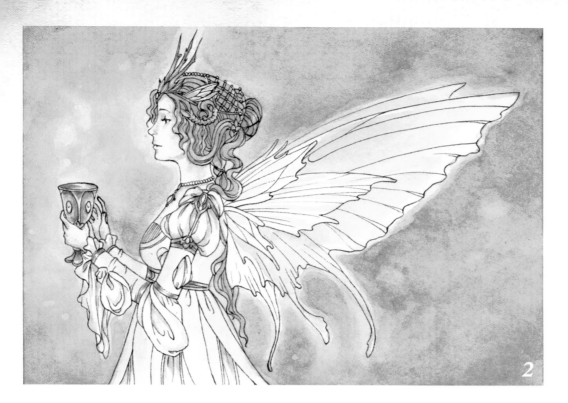

2

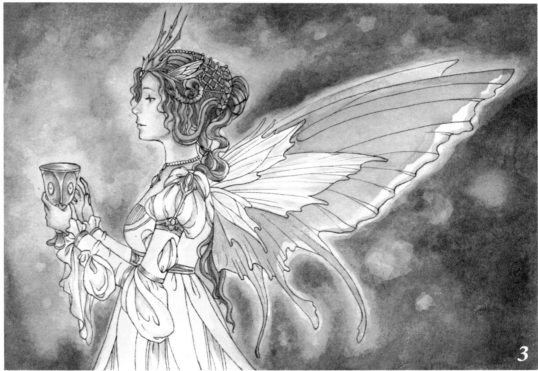

3

3 Color her Skin, Wings and Hair

Glaze her skin with a no. 2 brush and pale diluted Raw Sienna, painting a little darker over the purple shadows.

Using a no. 2 brush, color in most of the large wing with light Raw Umber, stopping short of the edge to leave a white space. Outline the outer edge with a thin line of Raw Umber. When dry, glaze pale Quinacridone Violet over most of the wing so that it fades out from the inside to the tip. Paint light Cerulean Blue over the small lower wing,

leaving the edge lighter. Then switch to a no. 0 and use pale Quinacridone Red to paint some of the sections in the small wings. Be sure to leave some of the yellow and white showing.

With a no. 4 brush, build up layers of Raw Umber over the background. Paint over the darkest areas and avoiding the lighter areas to create a glow. Then switch to a no. 0 to shade sections of her hair.

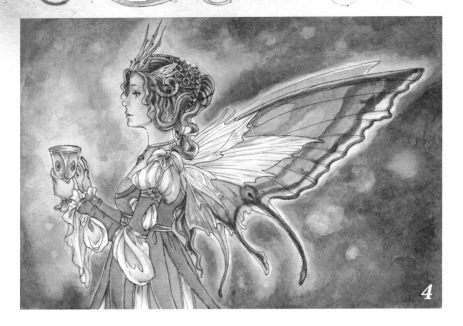

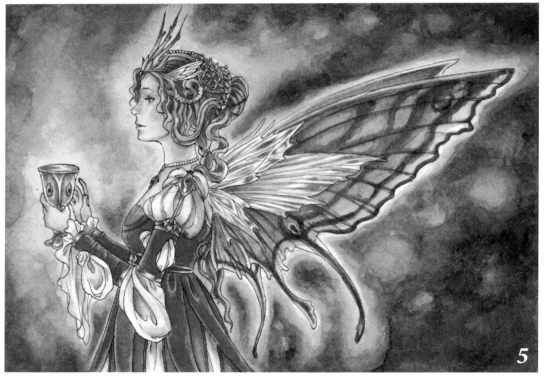

4 Begin Painting the Dress
Glaze her skin with light Brown Madder using no. 2 and 0 brushes. Darken the areas where shadows were previously painted. Make her lips and cheeks rosy using Cadmium Red thinned out. Use Raw Umber to glaze over the shadows on her blouse and white parts of her skirt. Add more shadows to her hair using a mix of Raw Umber and Burnt Sienna.

Using a no. 0 brush, add to the iridescent colors on the small wings with Phthalo Blue and Quinacridone Violet. Outline the blue wing with Cerulean Blue, and add blue to the eye spot on the larger wing. Switch to a no. 2 to paint the patterns on the largest wing. Paint the lighter stripes in the center with Burnt Sienna and let the color fade out. Then paint another darker layer over them with a mix of Burnt Sienna and Raw Umber. Darken the outline along the outer edges with Raw Umber.

Paint a base layer on the fairy's dress using Cadmium Red for the upper part and a mix of Quinacridone Violet and Dioxazine Purple for the underskirt. Color the small jewels with Quinacridone Violet, Dioxazine Purple and Phthalo Blue separately.

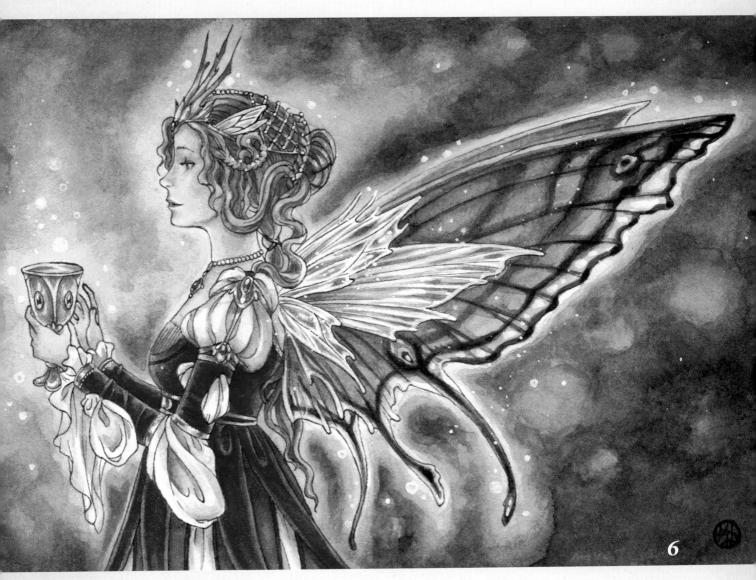

6

5 Add Details to the Wings and Darken the Background

Using a no. 4 brush, build up more layers of Raw Umber over the outer edges of the background, letting the color fade around the lightest glowing areas.

Paint the top section of the dress with Permanent Alizarin Crimson using a no. 2 brush. Leave lighter areas along the edges of the forms. Paint shadows on the underskirt with another layer of Quinacridone Violet mixed with Dioxazine Purple. Then dilute this mixture and glaze over the folds in the white cloth. With Burnt Sienna, deepen some of the color on the gold dress trim, crown and goblet.

Paint an outline of Cerulean Blue plus Payne's Gray along the blue wing using a no. 0. Glaze Raw Sienna over the light outer edge of the large wing. Then darken the stripes with Raw Umber. Paint transparent spots in the small wings where the brown shows through with Raw Umber.

6 Finish the Dress and Add Highlights

With a no. 0 brush, deepen the shadows and outline the sections on the purple underskirt with Quinacridone Violet and Dioxazine Purple. Mix Permanent Alizarin Crimson with Dioxazine Purple to paint shadows on the red parts of her dress. Leave lighter edges and outlines of folds to mimic velvet. Paint another layer with drybrush for the deepest shadows.

Outline the blue wing and color in her hair tie with Payne's Gray using a no. 0. Switch to a no. 2 and glaze the inner edges of the larger wing with Dioxazine Purple and Quinacridone Violet. Use Sepia to darken the outer stripes and eye spots and transparent parts of the small wings.

Finally, using White Gouache add highlights on the goblet, crown and gold trim using a no. 0. Dot small pearls in her hair and highlight and outline the smaller wings. Paint larger glowing spots by hand and then spatter smaller spots over the background and wings.

European Folk Costumes

FOLK COSTUMES BRING TO MIND fairy tales, and each country boasts its own versions of both. Traditional costumes identified with a particular country, or region, are most often worn for festivals and weddings now. Their history lies in the everyday wear of rural regions in the eighteenth and nineteenth centuries. Some traditional costumes keep details from the Renaissance or other periods. Dress varies by region in each country, often including colors and details that signify the owner's wealth, town or marital status. For the most part, aristocratic people often wore more modern clothing influenced by richer countries.

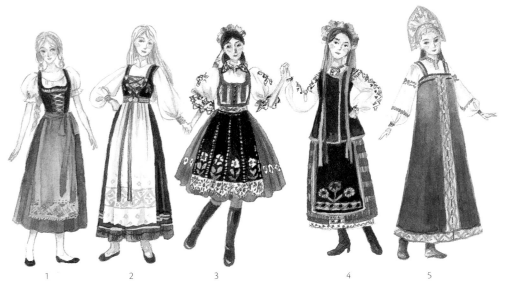

1 2 3 4 5

Traditional Folk Costumes

Most feature embroidered blouses and aprons or varying colors and cuts.

1. *Germany:* The dirndl is a simple dress and apron with a fitted bodice worn over a blouse.
2. *Norway:* The bunad dress is in black, blue or red with embroidery, apron and bodice with lacing or silver chains and clasps.
3. *Czech and Slovak:* The kroje includes a bell-shaped skirt and embroidered apron, vest and blouse with large puffy sleeves.
4. *Ukraine:* A straight skirt with an embroidered blouse is sometimes worn with a vest.
5. *Russia:* A long sarafan dress is worn with a blouse and arched headdress.

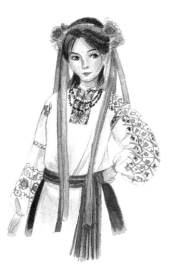

Embroidered Sleeves

Embroidery is a common decoration on blouses and aprons. Ukrainian designs tend to be red and black and run down the sleeve, while the Russian designs are mostly red bands around sleeves and cuffs. Slovak sleeves and collars are bordered in lacy black embroidery.

Geometric

Russian and Ukrainian embroidery is most often made of repeating geometric designs. Sometimes they feature animals, birds and folktales, all still very angular in shape. Embroidery is used around sleeves, cuffs and collars.

Organic Motifs

Here is an example of rustic floral Czech folk embroidery in red and yellow. Hungarian embroidery is characterized by large, stylized flowers of many colors over a white background with lacy edges.

Narrative Borders

DECORATIVE BORDERS can be more than just an extra decoration for an illustration. By bringing narrative elements into the border design, you can show more of the story. Repeating motifs or even small scenes illustrated in a corner are effective.

Motifs Within Borders

1. Make the entire border into a vine that twists and wraps around itself.
2. A forest motif inside a squared border can wrap around the corner as well.
3. Split the border into sections to fit multiple motifs, such as a forest, an apple and axes for a Snow White illustration.

Border Shapes

Choose a border shape according to how you intend to fill in the space. Fill the spaces around an arched top with a large motif or a scene. Make use of vertical spaces with repeating motifs or scrolling plants.

Scrolling Leaves

A grid of dots makes a useful guideline for placing winding vines or Celtic knotwork. Sketch your design and count the dots to space repeating elements evenly.

Narrative Elements

The horseman appears close to his destination. The thin vertical panel forces the story elements closer together. Draw the same scene horizontally to show a farther distance or longer passage of time.

Scrolls

Draw a scrolling length of paper if you wish to include a title or caption for an illustration. Place a scroll at the bottom or wrap twisting ends around a border.

Corners and Arches

Be creative with poses to fit figures into a space over an arch or use a central motif of a story element.

VASILISA THE BEAUTIFUL

*I*N THE RUSSIAN FOLKTALE of Vasilisa the Beautiful, a young girl is
forced to travel to the witch Baba Yaga to obtain fire. As she makes her
way through the forest, three horsemen pass her, each at a different time of
the day.

Deep in the forest stands Baba Yaga's log hut. After performing a series
of tasks for the witch with the help of a magical doll, Vasilisa runs home,
carrying an illuminated skull from Baba Yaga's gates.

MATERIALS

assorted brushes

hot-pressed watercolor
 paper

pen, pencil and water-
 proof ink

PAINTS

Alizarin Crimson

Brown Madder

Burnt Sienna

Cadmium Red

Cadmium Yellow

Cobalt Blue

Dioxazine Purple

Hooker's Green

Payne's Gray

Quinacridone Violet

Raw Sienna

Raw Umber

Sap Green

White Gouache

1 Paint the Base Color for the Background and Border

Paint pale Cadmium Yellow over the upper
background, then glaze Raw Sienna over it. Paint
a circle of yellow around the skull and in the eye
sockets. Paint very light Raw Umber over the lower
half of the ground and tree trunks in the foreground
while carefully avoiding the mushrooms.

With Raw Sienna fill in the sides of the border and
paint the scenes at the top.

2 Paint the Ground and Border

Paint the upper portion of the sky with light
Cobalt Blue. Paint the foreground with Raw Umber,
working around the mushrooms. Working in small
sections, paint wet-in-wet, dropping various colors
into the Raw Umber. Drop in Hooker's Green along
the sides and Cobalt Blue beneath her skirt. Use a
clean brush to lift out paint or drop in water for a
rocky texture.

Use Raw Sienna and Raw Umber to paint the
ground farther back.

With Raw Sienna shade the scenes at the top of
the border, the sides and bottom section, dropping in
Burnt Sienna toward the top to create a gradient.

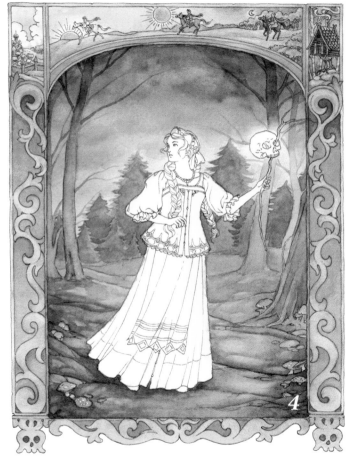

3 Build up the Background

For the top border, shade the scenes with a mix of Raw Sienna and Burnt Sienna. Mix in a little Raw Umber to paint the darkest values, like the horses and Baba Yaga's hut. Shade the sides with Burnt Sienna in the negative spaces, darkest toward the top.

For the interior of the image, glaze Raw Sienna over the lower sky and pines. Darken the sky with Cobalt Blue. Continue building up color in the foreground with Raw Umber. While wet, drop in more Cobalt Blue shadows under her skirt and a mix of Raw Umber, Sap Green and Raw Sienna around the sides. Dilute this mix to paint the ground farther back and the pines.

4 Paint the Trees and Mushrooms

Darken the negative spaces in the side border with Burnt Sienna. Mix in Raw Umber to paint the very top and the eyes of the skulls at the bottom. Paint the top arch and thin borders at the top with Raw Sienna and Burnt Sienna.

Darken the sky around the arch using Cobalt Blue plus Payne's Gray. Lift off some spots for clouds with a wet brush and then blot with a tissue. Paint the pines one at a time with a mix of Sap Green and Raw Sienna, then drop in a mix of Sap Green and Cobalt Blue. Paint the tree trunks on the right and left with Raw Umber and glaze with a layer of Payne's Gray. Paint the lighter trunks around the glowing skull with a pale mix of Raw Umber and Hooker's Green.

Mix Hooker's Green and Raw Umber to shade the ground. Paint the mushroom tops with Cadmium Red for the red caps and Raw Sienna and Raw Umber for the brown caps.

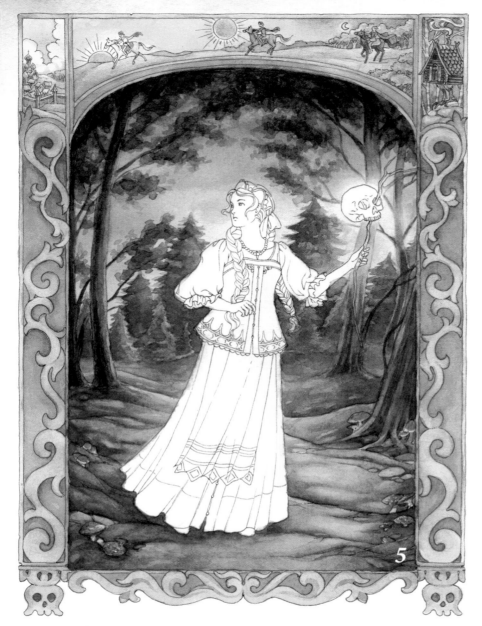

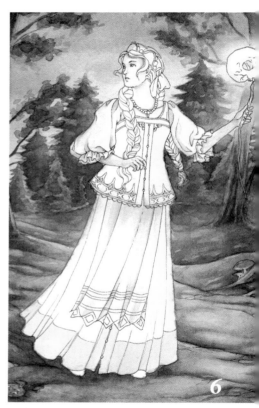

5 Paint the Background Foliage

Paint a mix of Sap Green and Raw Sienna over the ground nearest the pines. Mix in Cobalt Blue to paint the shadows of the pines on the ground. Suggest branches on the pines by painting shadows with Sap Green plus Cobalt Blue.

Shade the ground with a mix of Sap Green and Raw Umber followed by Payne's Gray along the dips in the ground and over shadow areas, and shade the lighter trees behind the skull. Add shadows to the mushrooms with Raw Umber and Burnt Sienna, and Alizarin Crimson plus Burnt Sienna on the red caps.

Darken the tree trunks on either side with Payne's Gray. Then add Cobalt Blue to the gray to dot leaves along the branches and the top edge near the arch.

Shade along the edges of the border scrollwork with Burnt Sienna. Mix Raw and Burnt Sienna to shade the scrolls toward the bottom.

6 Paint Shadows on the Skin and Dress

Paint reflected light on Vasilisa's dress and skin with light Cadmium Yellow. Paint yellow around the skull and in the eyes.

Paint Dioxazine Purple shadows on her skin away from the skull light and on her blouse and apron. Fill in the trim at the bottom of her skirt with Raw Sienna.

For more lessons incorporating myths and legends, go to impact-books.com/fairy-fantasy.

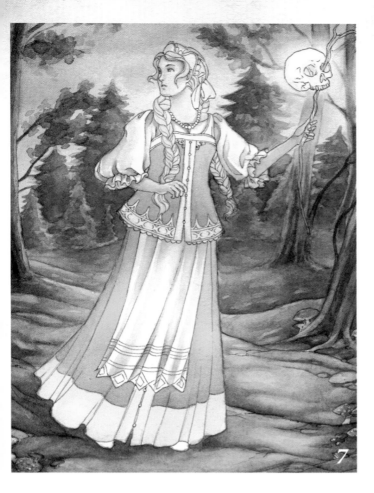

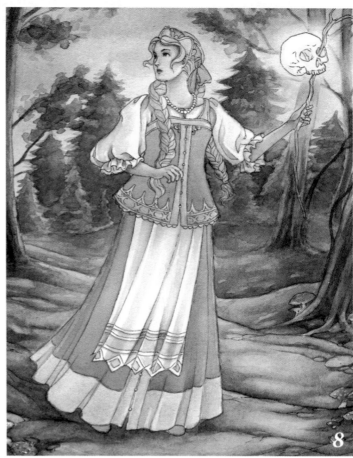

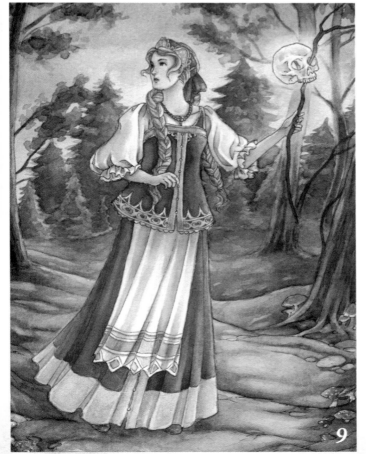

7 Paint the Dress

Glaze Raw Sienna over her skin and fill in her hair. Paint light Cadmium Yellow over her headdress and the trim on her vest. Glaze Raw Umber over the shadows on her blouse and apron. Paint a light layer of Cadmium Red over the rest of her dress, lighter toward the right.

8 Finish the Skin

Glaze Brown Madder over her skin and lips. Outline her eyes and the inside of her mouth with Raw Umber.

Paint darker Cadmium Red over her dress and hair bow, and shade the trim, headdress and hair with Raw Sienna. Paint some small transparent lace areas in her apron, using the same colors of the dress thinned out. Use light Payne's Gray to fill in her shoes.

9 Add Shadows to the Dress

Mix Raw and Burnt Sienna to shade her hair and the edge of her skirt lightly. Use more concentrated color to shade the trim on her vest and headdress. Fill in her necklace and the designs on the vest trim with Cadmium Red. Pick out some strands in her hair with Burnt Sienna.

Paint shadows on her dress and headdress using Cadmium Red plus Dioxazine Purple. Glaze Payne's Gray over the darkest shadows on her blouse, apron and shoes.

Add to the glow around the skull with Cadmium Yellow and shade with Raw Umber and Raw Sienna.

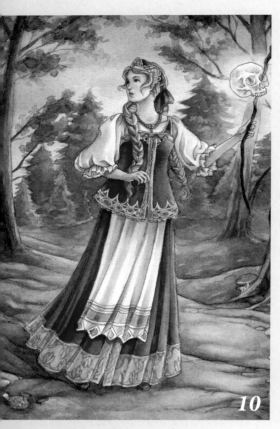

10

10 *Deepen the Shadows*
Mix Brown Madder and Quinacridone Violet to deepen some of the shadows on her skin. Darken the folds in her dress and on the left side of her vest with a mix of Alizarin Crimson and Dioxazine Purple. Paint a few deeper shadows on her vest trim and hair using Burnt Sienna plus purple. Then use this to paint the pattern along the top and bottom edges of her skirt trim. Add a few deeper shadows on the skull using a mix of Raw Umber and Payne's Gray.

Using Payne's Gray, deepen some shadows on the ground and tree trunks and paint a few thin branches.

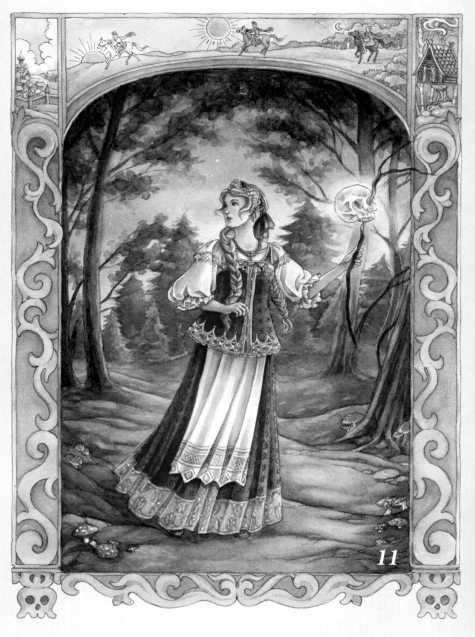

11

11 *Paint a Pattern on the Dress*
Paint the pattern of diamond shapes on her dress with Alizarin Crimson and Dioxazine Purple. Use Cadmium Red to paint the embroidered bands across her sleeves and collar. Then use White Gouache to paint a crosshatch pattern for the apron lace. Add small pearls to the bottom trim and her skirt and vest. Use white to paint stars in the blue sky and the small scene in the border, then spots on the mushrooms. Touch a little white on the trees and smoke behind Baba Yaga's hut. Paint the eyes in the skull with Raw Sienna, and finally, the light beaming out with thin white lines.

Japanese Clothing

THE JAPANESE KIMONO SILHOUETTE is very straight with padding used to disguise the shape of the figure. Each kimono is made entirely from one length of cloth, with all pattern pieces being rectangular. Because the garment can be easily laid out like a painting canvas, kimonos can be lavishly decorated with hand–painted designs.

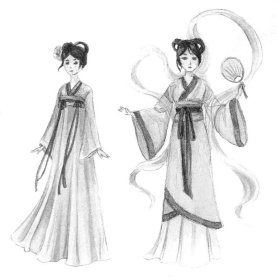

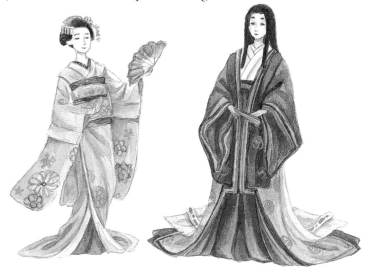

Kimono Variations

A maiko is an apprentice geisha. Her extra-long dancing kimono trails behind her and is more elaborately decorated than most. Since she in still in training, her sleeves and shoulders are made with tucks to resemble a child's kimono that has been made smaller. Her under-kimono and collar are always red until she graduates. The obi is wider and longer, with the ends hanging at the back. She wears a floral kanzashi hair ornament on her right side.

A Heian Princess

A jūnihitoe is a twelve-layered silk kimono worn by medieval court women in the Heian era. Multicolored silk robes are worn over a long red pleated skirt. A long white train hangs from the back of the waist. The colors of the robes are only visible at the sleeves and neckline. Color combinations can show a noblewoman's rank or her good taste. Jūnihitoe create a feeling of nostalgia and are pictured in many illustrations from *The Tale of Genji*.

Chinese Dress

The historical costume of the Han Chinese, called hanfu, was worn before the seventeenth century and formed the basis for the Japanese kimono. Hanfu costumes are common in Chinese historical fantasy comics and movies. Many variations exist, from long robes tied at the waist with a sash worn over a skirt, or paired with a skirt over a robe. Accessories include long sashes and ornaments of jade and braided cord attached to the waist.

Tabi Socks and Sandals

Geta are wooden sandals on two platforms. Zori sandals are similar but lack the feet. Both are worn with two-toed socks made of white fabric.

Sleeves

When arms are bent, the top of the sleeve drapes over and appears like a fold. The tail of the sleeve hangs down behind when her arm is at her side. It's helpful to study historical Japanese prints or photos for reference.

Hairstyles

Traditional hairstyles are waxed at the front and pulled into buns or loops that are held with combs and pins.

Heian ladies wear their hair extremely long and trimmed only around the face. Eyebrows are shaven and drawn higher on the forehead with makeup.

Kimono Patterns

KIMONOS FABRIC is decorated with a combination of dying techniques, embroidery or woven patterns. The motifs are mainly botanical and designed to be worn seasonally with some plants conveying a symbolic meaning. Designs tend to be elaborate, sometimes showing an entire landscape with birds and animals.

Patterns and placement can indicate the wearer's age or a level of formality. Formal kimonos are mostly patterned at the bottom edge, sleeves and shoulder—sometimes with round family seals on the shoulders. A plain or small pattern is considered informal.

Fall
Themes used in a fall kimono include chrysanthemums, falling leaves such as Japanese maple or ginkgo, chestnuts and persimmons. Popular motifs related to fall moongazing include the harvest moon and the rabbit in the moon.

Spring
Spring is synonymous with the cherry blossom and is depicted with both flowering and falling petals later in the season. Other motifs are wisteria, peonies and irises. Butterflies, birds, koi fish and streaming water are also indicative of spring.

Summer
Summer motifs include flowers, water, rain, waves and scenes of the sea. Flowers and plants include irises, bamboo, willow, lilies, water lilies and morning glories. Other symbols include wind chimes, goldfish, festival scenes and fireflies.

Winter
Pine, bamboo and plum blossoms are the most popular winter motifs. These are plants that endure the winter weather, known as the "three friends of winter," and have been popular subjects in traditional Chinese brush painting. Other winter motifs include camellia blossoms, snow and snowflakes, moon and stars and orchids.

Autumn Pattern
Combine chrysanthemums with maple leaves and a geometric pattern. Paint around the lighter flowers, then paint the darker leaves over the background color. Mix watercolors with White Gouache to add final details.

Spring Pattern
This peonies and cherry blossom pattern is perfect for spring. Mask the flowers, then paint and shade the surrounding color. Remove the masking, paint the flowers and add details with White Gouache and gold paint.

PAINT A JAPANESE FOX SPIRIT

KITSUNE

\mathscr{F}OX SPIRITS, called "kitsune" in Japanese, are well-known figures in Japanese, Chinese and Korean folklore. These long-lived foxes are believed to possess magical powers and gain more tails as they become older, finally having nine tails at their oldest and most powerful. Many stories feature foxes who disguise themselves as humans to create mischief or remain human for love.

The fox maiden dances beneath a twisting Japanese maple tree, calling her ghostly fox sisters into physical form through the mists. The blue and red provide a striking contrast to the orange foxes and subdued background colors.

MATERIALS

assorted brushes

hot-pressed watercolor
 paper

pens, pencils and water-
 proof ink

PAINTS

Alizarin Crimson

Brown Madder

Burnt Sienna

Cadmium Red

Cadmium Orange

Cadmium Yellow

Cerulean Blue

Cobalt Blue

Lamp Black

Payne's Gray

Phthalo Blue

Quinacridone Red

Quinacridone Violet

Raw Sienna

Raw Umber

White Gouache

Yellow Ochre

1 *Paint the Hazy Background Base*
Paint with light Raw Umber lightly over the background, avoiding the wispy smoke outline. Paint the darkest layers along the edges of the smoke and tree, then blend outward with clean water. Paint another layer over the tree, with a lighter color under the smoke. Working wet-in-wet, darken the ground along the tree base and behind the figure.

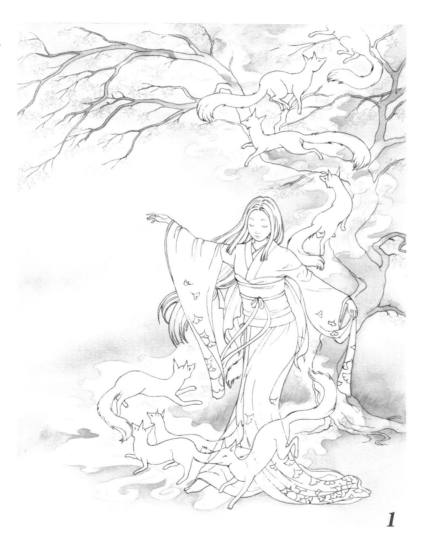

1

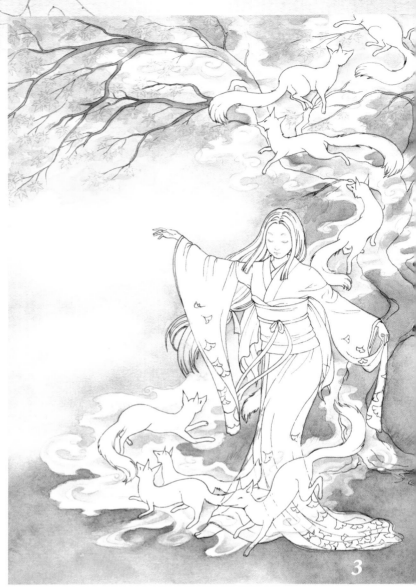

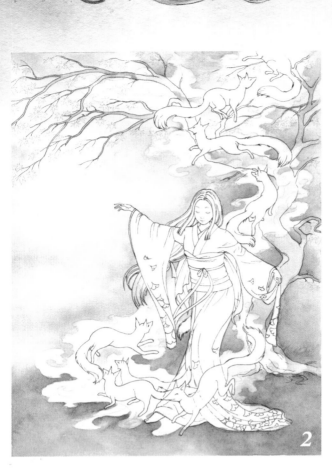

2 Deepen the Background Shades
Deepen the color along the horizon behind the tree and around the figures with Raw Umber. Paint Burnt Sienna along the ground and grassy edge along the bottom. Drop in some Cobalt Blue for the deepest shadows. Paint around the base of the figures and foreground with Raw Umber. While wet, drop in small amounts of light Cobalt Blue and allow the colors to flow together. Let dry, then paint another layer using the same technique and drop in spots of clean water to create a rocky texture. Make the darkest areas around the edge of the bottom mists and the kimono.

Add some misty texture at the left side with very light Raw Umber. Paint some of the shadows inside the mists and branches with Raw Umber.

3 Indicate Hazy Background Foliage
Use light Yellow Ochre and Burnt Sienna to dab around the tree leaves. Then paint light Raw Umber over the branches and trunk.

4 Paint the Leaves and Trunk
Make a mix of Burnt Sienna and Yellow Ochre to paint the maple leaves and the wispy grass behind the tree and figure. Drop a mix of Raw Umber and Cobalt Blue into some of the grassy area.

Use Raw Umber to deepen the shadows on the ground, dropping in more Cobalt Blue over the darkest areas. Paint some small circular shapes for rocks and blend the edges together. Use Raw Umber to darken the tree trunk and branches. While wet, lift out some of the color along the trunk and center of the branches with a clean wet brush.

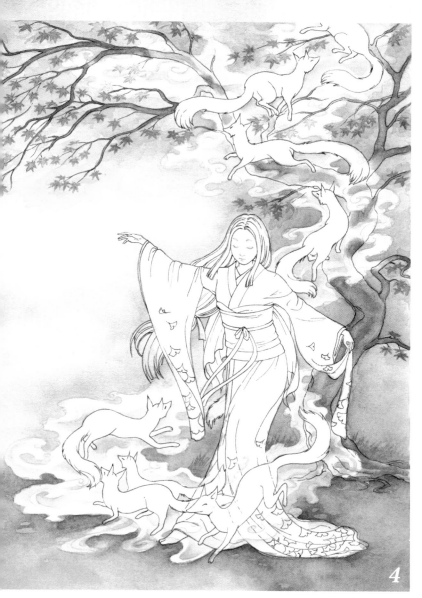

4

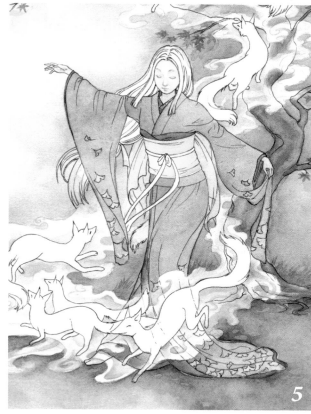

5

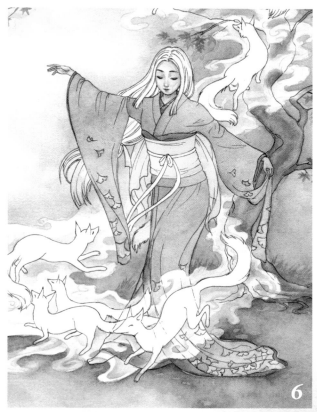

6

5 *Create the Kimono and Skin Base Layers*
Begin painting the skin with very light Raw Sienna. Add Cadmium Yellow to the Raw Sienna for her obi belt, then paint the ginkgo leaf pattern on her kimono. Paint the red linings and under-skirt with Cadmium Red. Paint the main color of the kimono with a layer of Cerulean Blue. When this is dry, mix in Phthalo Blue and glaze another layer over the kimono. Paint a little of the red and blue colors very lightly in the mists to make them transparent.

6 *Finish the Skin Tones*
Paint the midtones on her skin with Burnt Sienna, then glaze Brown Madder for the rosy tones on her cheeks and above her eyes, under the chin and on her fingertips. Paint her lips with Brown Madder and a touch of Alizarin Crimson. Add a little light Quinacridone Violet in the shadows on her neck and under her nose and hairline. Paint her eyes and eyebrows with Payne's Gray.

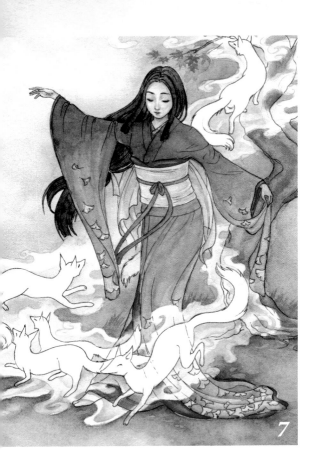

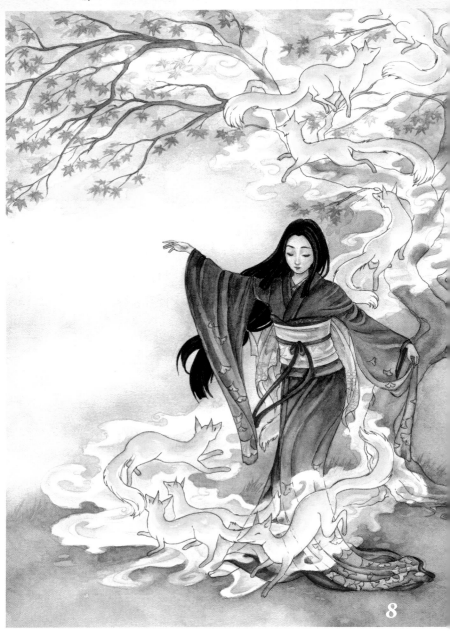

7 Glaze the Kimono
Begin shading the folds in the kimono along the bottom edge and top of the sleeves with Cobalt Blue. Next, thin out the Cobalt Blue and glaze over most of the kimono, making it lighter at the bottom. Make a mix of Phthalo Blue and Payne's Gray, and paint along the top of the sleeves. Blend downward. Try to make a smooth gradient of color from top to bottom.

Shade the obi belt with Raw Sienna, making it darker at the right edge. Create shadows on all of the red parts with Alizarin Crimson. Paint the obijime with Cadmium Red after the areas around it have dried. Shade the hair tie with Raw Sienna and paint her hair with Payne's Gray.

8 Deepen the Fabric Folds and Begin the Foxes
Darken the top edges of the kimono and add more shadows to the wrinkles with Payne's Gray plus Phthalo Blue. Mix in Cobalt Blue to make it a little lighter for lower sections. Use Raw Sienna and Burnt Sienna each mixed with Cadmium Orange to paint maple leaf shapes and outlines on the obi. Shade the ginkgo leaf pattern with Raw Sienna as well. Shade the obijime with Alizarin Crimson and darken the shadows on the other red parts of the kimono. Shade the lady's hair with Lamp Black.

Paint Raw Sienna along the foxes' backs, legs and top of her head. The foxes should stay somewhat pale and ghostly.

9 Add Details

Glaze pale Cadmium Red over the upper inside of the obi tails. Add details to the leaf pattern with more concentrated Cadmium Red. Darken the red part of the foxes with another layer of Raw Sienna. Paint the transparent parts of the foremost ghost fox with Cobalt Blue, Raw Umber and Cadmium Red.

Create the bark texture of the tree trunk and darken the upper branches with Raw Umber. Darken the leaves with a mix of Cadmium Red and Burnt Sienna. Use light Raw Umber to lightly outline the mists.

10 Finalize Details and Highlights

Add some faint leaves around the edges of the mists in the tree with a mix of Burnt Sienna and Yellow Ochre. Work on the foxes using Burnt Sienna, making the legs and ears the darkest.

Use White Gouache to outline the transparent edges of the foxes where the background shows through and the edges of the mists. Paint ginkgo leaves and a star pattern on the kimono with small white dots. Add a few highlights and embroidery texture details with small white strokes on the obi.

Finally, add blush on the lady's cheeks with very pale Quinacridone Red.

PART FOUR

Modern Fantasies

WITH MANY surviving examples of garments in museums, studying the fashions of more recent history is easy. Recent centuries can lend design elements both familiar and foreign to your fantastical vision. You may mix together elegant fashions, historical events, photographic inspirations, architecture and mechanical details from eras past. Add in your own retro-futurism to make steampunk, for instance, or capture alternate pasts where mermaids swim in the seas and dragons fly through the air.

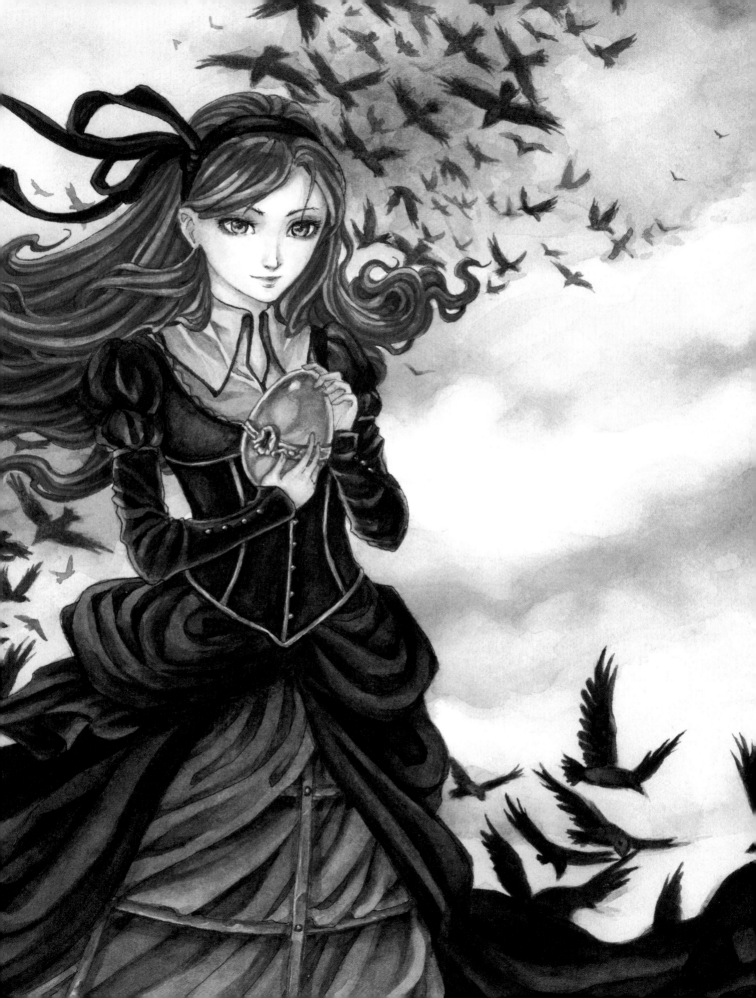

Eighteenth-Century Rococo Fashions

LATE EIGHTEENTH-CENTURY ROCOCO FASHION was decadent, decorative and feminine. Marie Antoinette was considered the height of fashion. Curving shapes, along with gold and pastel colors, dominated along with a profusion of frills and ruffles. Dress styles were characterized by the back being different from the front. Women's dresses were very wide and used a rectangular hoop skirt called a pannier. Court dresses were even wider and required going through doors sideways.

Men wore long coats and vests with short breeches and stockings. Embroidered fabrics were used for formal wear.

Robe à la Française
Also called a sacque-backed gown, this was a formal dress with long pleats flowing from the shoulders and obscuring the waist in the back. The front revealed the petticoat. Bodices could be decorated with an interchangeable front panel called a stomacher.

Robe Polonaise
The overskirt was gathered up toward the back with ties or buttons, exposing the underskirt. This style was less formal than the robe à la française.

Hairstyles
In the 1770s, hair was piled up high, often over pads or fake hair, with curls on the sides and back. Hairstyles were decorated with ribbons, flowers, leaves, birds or even entire model ships for fancy balls. In the 1780s, hair was worn out to the sides.

Robe à L'anglaise
Similar to the sacque-backed gown in front, but this gown has shoulder pleats sewn into the back of the bodice and full at the waist. The man wore a long coat over a waistcoat, breeches and stockings.

Sleeves and Cuffs
These were mainly straight and elbow length, finished with pleats of ruffled lace. Lace cuffs made up of many layers attached separately. The lace, made by hand, was expensive and used to show off wealth.

Masks and Masquerade

MASQUERADE BALLS STARTED IN VENICE with the annual Carnivale in the fifteenth century and were popular in France and England throughout the eighteenth and nineteenth centuries. People dressed as romanticized versions of historical figures, historical dress or foreign countries, as well as themes from the natural world such as seasons, flowers, insects or day and night. Balls were elaborate and theatrical with sets matching a theme.

Basic Masks

Masks came from Venice where mask makers held high status. Venetian masks are known for their decorative swirling gold patterns and can fit full-face or cover just the top half. Masks can be tied to the wearer or held up on a stick or wand. Wearing a mask was a way for people to transcend social classes for a few days a year.

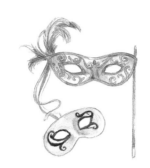

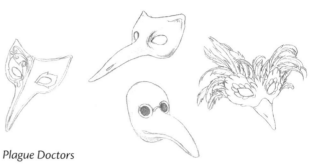

Plague Doctors

These bird-shaped masks with round eyes were inspired by masks worn by doctors who treated plague victims. This is a good starting point to experiment with the nose shape and create bird or animal masks.

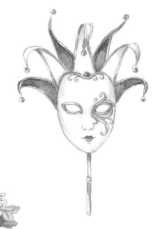

Animal Masks

Animal and plant-based masks and costumes are particularly effective combined with makeup. They can be made of leather, wood, ceramic or fabric with flowers, leaves and feathers. A cat-eared mask is one of the traditional Venetian styles.

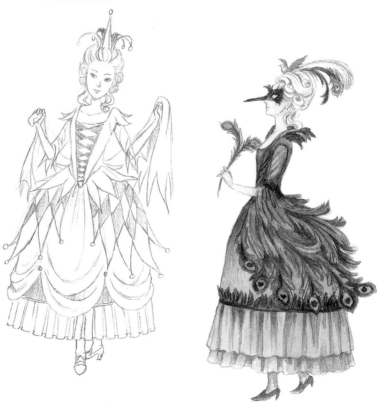

Harlequin and Peacock Costumes

A layered skirt offers the possibility to draw different materials or colors in one dress. Create a flower skirt by layering fabric petals, or an animal or bird by using a fur or feather pattern. To draw costumes for historical characters, follow the silhouette of the time period for your character, but use details from their chosen historical period.

FOREST FINERY

MANY CULTURES REVERE DEER as otherworldly or messengers from the Fairy realms. Many mythologies tell of gods who sometimes disguised themselves as deer or possessed horns of their own. Many Celtic stories exist of fairy women changing into the form of a deer.

Dressed for a masquerade ball, a mysterious lady is clothed in the colors and textures of the autumnal forest. She carries a staff bearing shining baubles and amulets. Might she be a fairy herself, or merely dressed as one?

MATERIALS

assorted brushes

hot-pressed watercolor paper

pens, pencils and waterproof ink

PAINTS

Alizarin Crimson

Brown Madder

Burnt Sienna

Cadmium Orange

Cadmium Red

Cadmium Yellow

Cerulean Blue

Cobalt Blue

Dioxazine Purple

Hooker's Green

Payne's Gray

Quinacridone Red

Quinacridone Violet

Raw Sienna

Raw Umber

Sap Green

Sepia

Viridian

White Gouache

Yellow Ochre

1 Build Color Around the Frame

Sketch the figure and frame in pencil. Use waterproof ink to outline the figure, but leave the frame in pencil. Wet the paper around the center frame, then painting wet-in-wet, use Burnt Sienna and Yellow Ochre. Blend the color out to the edges until the whole area is a light yellowish color. Drop in more color in a few random spots and the bottom edge and corners.

Paint the inside of the circle with very light Yellow Ochre plus a little Burnt Sienna. Paint around the figure and the frame edges, blending the color out with clear water. Paint the outer frame with a more concentrated mix of the same color, also blending the edges outward. Paint some uneven splotches to create a parchment feeling. Darken the color around the leaves and between the parts of the frame.

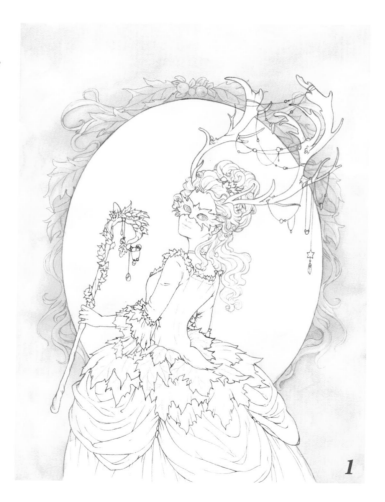

1

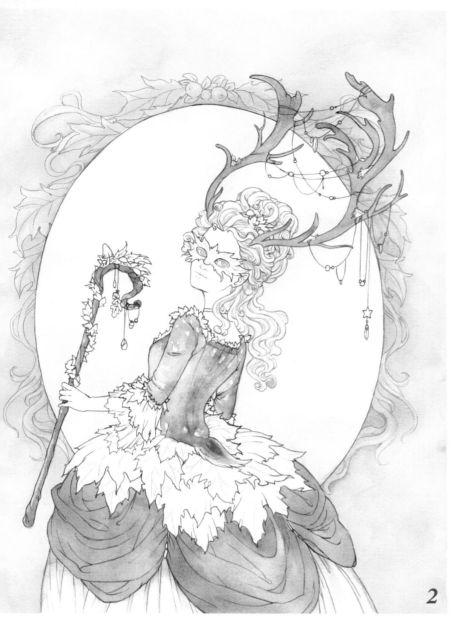

2

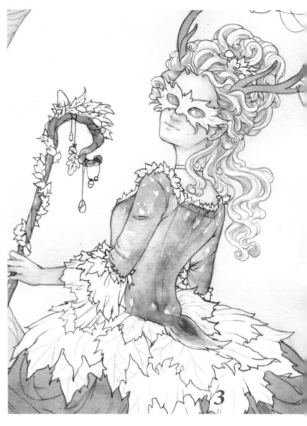

3

2 Begin the Figure

Paint her hair with very light Raw Umber. Concentrate on lightly shading the larger forms. Add light shadows to her underskirt with Payne's Gray plus Burnt Sienna. Paint around the top edge of the skirt and blend downward with clean water. When this is dry, shade the individual folds with light gray.

Mix Burnt Sienna and Yellow Ochre to paint her bodice and staff. Start with a scribbling motion, then fill in the space between the circles. Darken down the center of her back and the backs of her sleeves with more Burnt Sienna.

Paint the gathered overskirt with a mix of Burnt Sienna, Yellow Ochre and Raw Umber. Paint from the top edges and blend downward. Darken some of the deeper folds with the same color while wet. Shade the staff and antlers.

3 Paint Her Skin

Begin painting shadows on her skin with Dioxazine Purple. Paint slightly darker shadows in her hair with a mix of Payne's Gray and Dioxazine Purple.

Coat her skin with a very pale Raw Sienna, adding a second layer over the darkest shadows.

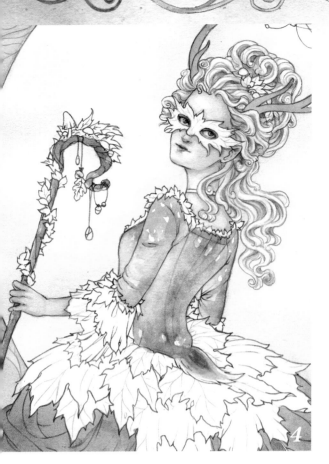

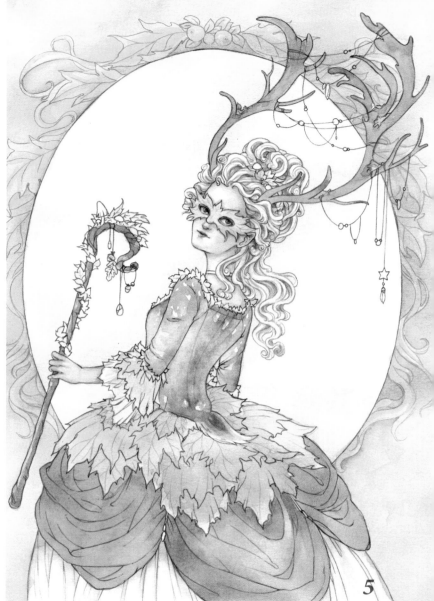

4 Finish the Skin

Darken the shadows and edges around her hair with Brown Madder. Add a little blush to her cheeks with very pale Quinacridone Red. Paint her lips with a light Brown Madder and between them with Raw Umber plus Alizarin Crimson. Paint light Brown Madder to shade around the eyes. Outline the top of her eyes with Raw Umber plus Payne's Gray. Paint in the irises with a mix of Sap Green and Raw Sienna.

Finally, pick out a few strands of hair with Sepia.

5 Paint the Leafy Skirt

Mix light Yellow Ochre and Raw Sienna to paint a layer over the leafy skirt and mask. Add a bit of Raw Sienna on the outer edges of the mask.

Paint more Raw Sienna over the left side of her leaf skirt, adding a little light Cadmium Red while wet. Do the same to the center, using Sap Green mixed with a little Raw Sienna. Use less green toward the far right side, allowing the yellow to show through. Paint Yellow Ochre on her staff leaves and in her hair and sleeves. Glaze Sap Green over that and paint the moss on the antlers.

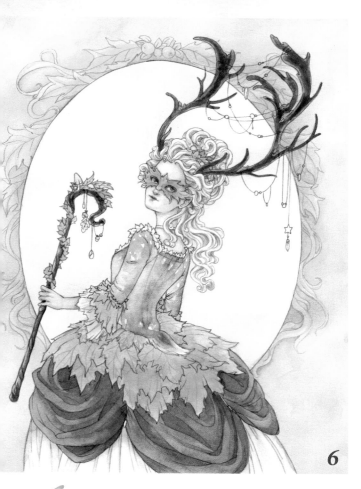

6

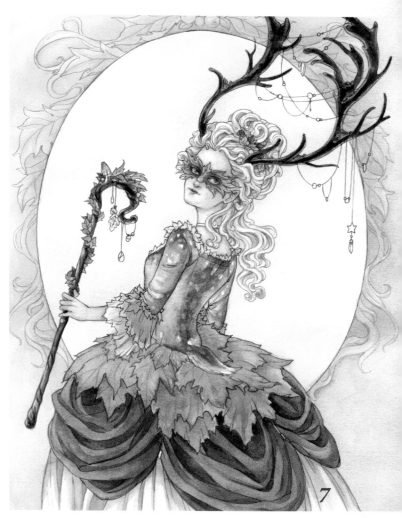

7

6 Add Midtones

Mix Burnt Sienna and Raw Umber to paint her antlers. Paint the darkest color toward the center and blend to the edges to give the antlers a fuzzy look. Paint the same color along the right side of the staff and blend toward the left to add a gnarled texture effect to the wood.

Paint the gathered skirt with a mix of Sepia and Dioxazine Purple. Paint along the right sides of each section, blending toward the left. Create some depth in the larger folds while still wet. Add Burnt Sienna to the mix to paint the smaller wrinkles.

Paint Yellow Ochre over the edge of the leaves on her skirt. Outline the edge of the green leaves and blend inward. While still wet, drop in Sap Green on the right and Cadmium Orange toward the left. Add Cadmium Red over the orange and drop some under the edges of the green leaves. Use Sap Green to shade her sleeve ruffles.

Paint Yellow Ochre over her mask, the leaves in her hair and the top of the staff. While wet, paint Sap Green on the mask and some of the leaves, and a mix of yellow and green on others. Make one leaf in her hair orange. Paint light Raw Sienna over the mushrooms. Darken the moss on her antlers with Sap Green as well.

7 Deepen the Dress Colors

Deepen the shadows in the folds on the brown skirt using Sepia mixed with Burnt Sienna. Then use Sepia by itself for darker shadows directly under the leaves.

Paint very light Sepia shadows over her white underskirt. Then drybrush deeper color on her antlers.

Use Burnt Sienna to darken the color along the center of her back, the backs of her sleeves and shoulders. Leave some spots unpainted and blend the color out toward lighter areas. Lift out some spots with a clean brush.

Apply Hooker's Green on the mask from the nose to the tips on each side. Create small leaf veins on the mask. Add darker color to the leaves in her hair. Dot Hooker's Green into the moss on her antlers and soften with clean water. Paint some of the small leaves with Hooker's Green mixed with either Yellow Ochre or Quinacridone Red for varied greens. Paint some of the mushrooms with Burnt Sienna plus Raw Umber or Cadmium Red for others.

Mix Hooker's Green and Sap Green to darken the shadows around the skirt leaves and the sleeve ruffle. Mix Cadmium Red and Orange to line the edges of some of the leaves. Blend inward.

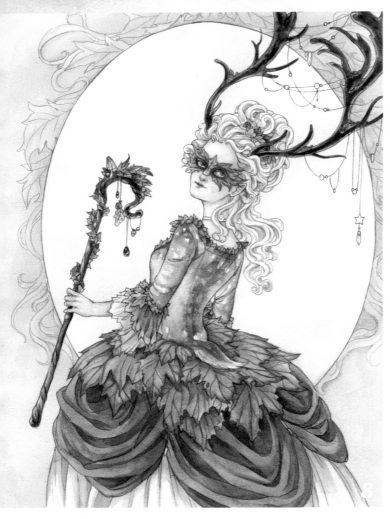

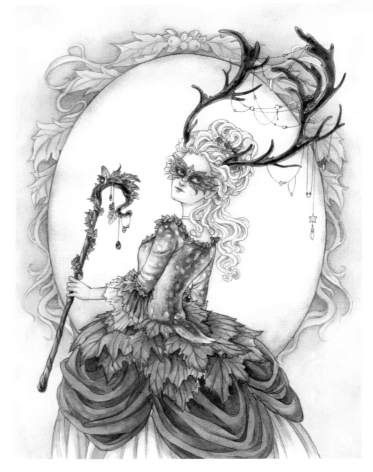

8 Detail the Leafy Skirt and Mask

Mix Hooker's Green and Cobalt Blue to line the inner edges of the eye holes in the mask and to paint shadows on smaller leaves, and green leaves on the skirt. Outline the outside of the mask with Alizarin Crimson and Cadmium Orange.

Paint Alizarin Crimson around the edges of the skirt leaves. Create the thin veins in the leaves with a smaller brush. Paint diluted color between some of the veins, leaving space around the edges. Indicate veins on the green leaves with Hooker's Green.

Create the wrinkles in the sleeve ruffle by painting Hooker's Green between the folds. Then glaze Yellow Ochre and Cadmium Orange on the lower ruffle. Paint the leafy border on her collar using light Sap Green, and while wet, dot in Hooker's Green plus Cerulean Blue. When dry, define the shadows with Hooker's Green.

Paint the jewels on the staff with Alizarin Crimson and Dioxazine Purple, reserving some light parts and white highlights. Use Alizarin Crimson and Cadmium Orange to outline the lighter leaves on the staff and Yellow Ochre and Burnt Sienna on the hanging leaf and acorns.

9 Darken the Inner Circle and Glaze the Skirt

Fill in the negative spaces in the frame with Burnt Sienna and blend outward. When the frame is dry, glaze Yellow Ochre around the entire frame and blend outward. Line the inside of the frame with light Raw Umber and blend inward with clear water.

Deepen the shadows between the leaf layers with Cadmium Red mixed with a touch of Dioxazine Purple. Then glaze light Hooker's Green plus Cobalt Blue over the white underskirt at the center and right. Do the same with Burnt Sienna on the left side.

Paint Yellow Ochre over some of the upper hanging beads.

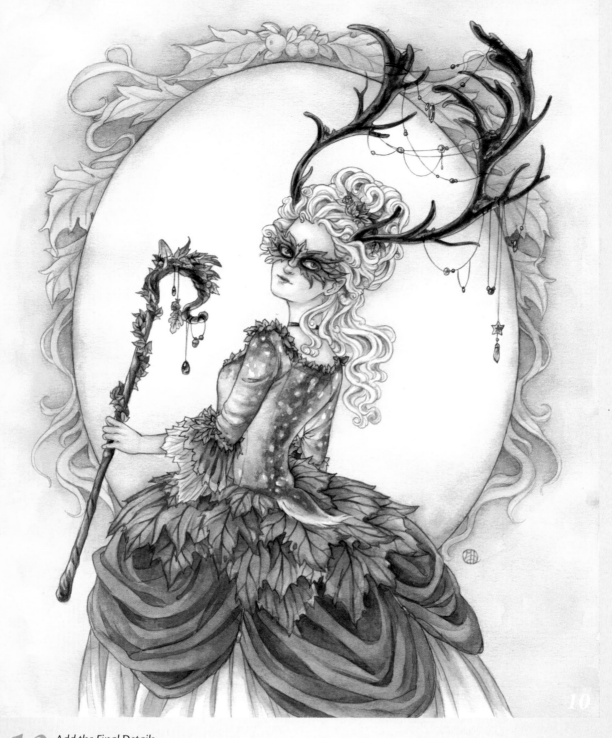

10 Add the Final Details

Paint various colors on the beads and jewels hanging from her antlers in Quinacridone Violet, Cobalt Blue, Cerulean Blue, Alizarin Crimson, Viridian and Cadmium Yellow. Shade the yellow beads, star and oak leaf on the staff with Yellow Ochre and Burnt Sienna.

Paint her choker from front to back with Cadmium Orange, Alizarin Crimson and Dioxazine Purple.

Darken the small veins on the mask and green leaves with Hooker's Green plus Payne's Gray, then with Sap Green on the lower sleeve ruffle. Use Alizarin Crimson for veins on the orange leaves.

With White Gouache, create highlights on the jewels, knuckles, lower sleeve ruffle and acorns. Paint short strokes of white to indicate fur on the edge of her tail, and dot white onto the red mushrooms.

Paint very diluted white on the antler edges, then drybrush the darkest parts with Sepia. Finally, darken the strings that wrap around the antlers with Payne's Gray.

Victorian Fashion

THE VICTORIAN SILHOUETTE is unmistakable. A woman's natural silhouette was changed with the help of padding, corsets and bustles into the fashionable figure of the time. Costumes were profusely trimmed with fringes, ribbons, braids, beads and furs, and were quite heavy.

COLOR POSSIBILITIES

The color possibilities became endless with new synthetic dyes created in 1856, which could produce bright purple, magenta, blue or yellow. While men wore mostly somber colors, women had a wider range.

TAKING INSPIRATION

Since the ornateness of Victorian dress can look stiff, it's best to take inspiration from one aspect for your own interpretation. A bustle or corset can be combined with shorter skirts or the ornate trims of the period used for decoration.

Corsets

Previous to the Victorian era, corsets were cone-shaped and used bone or wood for the form. Steel began to be used in the nineteenth century with more exaggerated shaping. The corset became longer and extended over the hips. Steel bones were encased in stitched channels. Study where these are placed, but drawing just a few creates the right look.

The Bustle

The icon of Victorian fashion went in and out of style during the second half of the nineteenth century. A bustle consisted of a series of hoops attached at the back, which, when worn under a skirt, filled out the form of the skirt. Skirts and trains of gathered fabric were worn over the bustle. Create a bustle look without bulk by drawing skirts gathered up toward the back.

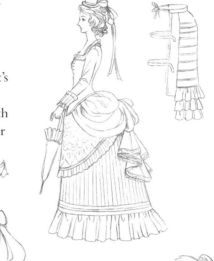

Evening Wear

She wore a formal ball gown with a low neckline and long bustled train, decorated with large bows. The front had two layers trimmed with lace and flowers over a pleated skirt. Gloves and fans were indispensable accessories for evening wear. Light colors were considered proper for evening attire.

Hair

Victorian hairstyles included lots of curls and braids twisted and piled high. Hair extensions and braids were pinned into natural hair.

Popular styles included a curled hairstyle decorated with flowers, a small lace cap tied at the chin and the Gibson Girl bouffant style of the 1890s.

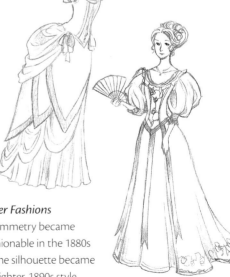

Later Fashions

Asymmetry became fashionable in the 1880s as the silhouette became straighter. 1890s style was simpler in decoration with no bustle and featured large ballooned sleeves and hair.

Rough Stone

TOWERING WALLS of stone and ancient weathered ruins can create a mysterious setting for a fantasy painting.

To paint a smooth stone-like marble, paint a base color. While wet, paint darker streaks with a smaller brush. Experiment with painting wet-in-wet or dry-into-dry, then blending.

MATERIALS

assorted brushes

hot-pressed watercolor paper

PAINTS

Payne's Gray

1 *Applying the Base Color*
Paint a flat wash of Payne's Gray and let dry.

2 *Add Color Variation*
Add shadows around the forms and blend out toward the edges until the brush runs out of paint and creates a rough texture.

3 *Add Shadows*
Darken small openings inside the arch and around the top. Draw jagged lines with the brush diagonally across the inside. Then with clean water, soften some of the lines by painting clean water over them. Do the same to the outside, but paint larger shapes. Pick out irregularities in the base color and darken those areas. Make sure to leave some unpainted spots. When dry, paint very light Payne's Gray over the arch outline.

4 *Paint the Cracks*
Add deeper shadows to some of the darkest areas and corners. Pick out places that look like cracks or pits in the stone and darken them. Draw thin, jagged lines for cracks. Use clean water to soften some of the cracks.

Gothic Stained-Glass Windows

GOTHIC-STYLE CHURCH WINDOWS come from the Medieval age, but are a common theme in modern Gothic fantasy art. Window shapes create an interesting background or border, and the same shapes can be painted as stonework.

To capture the qualities of sun shining through stained-glass windows, use bright pure colors. Since they are made of handmade glass, add irregular texture to the surface.

MATERIALS

assorted brushes

hot-pressed watercolor paper

pen, pencil and waterproof ink

PAINTS

Cadmium Orange

Cadmium Red

Cadmium Yellow

Cobalt Blue

Dioxazine Purple

Sap Green

Viridian

1. A basic three-sided trefoil shape within a circle.
2. Stretch and squash the trefoil into a rounded triangle to make points.
3. A simple tear shape can be twisted and mirrored to fit around other shapes.
4. This shape fits around the top edge of an arch or in a corner.

1 Apply the Base Color
Draw and ink the outline of a window. Paint the base color. Use Cadmium Yellow in the center, Cadmium Orange in the outer circles, then Cadmium Red and Sap Green for the leaves and Cobalt Blue at the edges.

Paint more concentrated values of the same colors around the edges of each shape and blend inward.

2 Add Depth
Mix Cadmium Yellow and Cadmium Orange to paint around the center circle and blend inward. Darken the inner edges of the leaves with a Viridian glaze.

Paint more Cadmium Red over the red areas and Cobalt Blue around the edges of the blue. Mix Cadmium Orange with Cadmium Red and paint around the edges of the round orange shapes. Paint along the center lines of the glass pieces in the orange and blue sections, with orange and blue paint, respectively.

3 Add Texture and Outlines
Paint irregular lines and leave open spots and streaks to create texture on the glass. Glaze Dioxazine Purple around the edges of the blue and red glass. Mix a little Cobalt Blue with Sap Green and glaze one side of each leaf. Paint detail over the orange with Cadmium Orange and Red. Paint Cadmium Yellow plus Orange around the center circle.

PAINT A VICTORIAN LADY
WINGED SISTERS

*J*EWEL-COLORED LIGHT SHINES through the Gothic window, illuminating a fairy lady as she meets her winged butterfly sisters. Her dress is inspired by Victorian fashions, incorporating brightly colored wings that mimic stained glass in the skirt.

MATERIALS

assorted brushes

hot-pressed watercolor paper

pens, pencil and water-proof ink

PAINTS

Alizarin Crimson

Brown Madder

Burnt Sienna

Cadmium Orange

Cadmium Red

Cadmium Yellow

Cerulean Blue

Cobalt Blue

Dioxazine Purple

Hooker's Green

Lamp Black

Payne's Gray

Quinacridone Red

Quinacridone Violet

Raw Sienna

Raw Umber

Sepia

Ultramarine Violet Deep

White Gouache

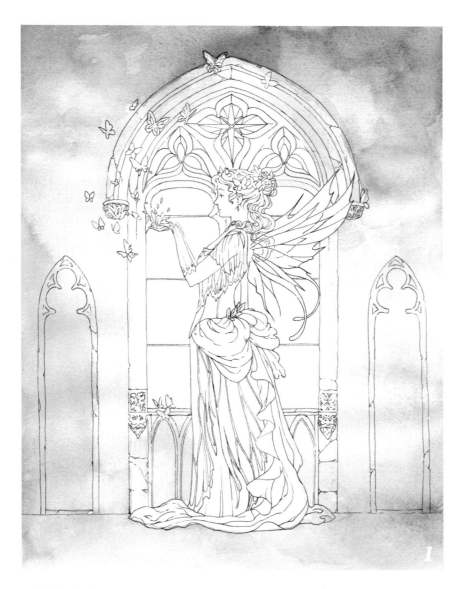

1 Paint the Stone

Using Ultramarine Violet Deep, paint a base layer over the background, avoiding the figure and butterflies. Make the corners and outer edges darkest. While the background is wet, add more color into the darker areas, then mix Ultramarine Violet Deep and Payne's Gray to darken the upper corners and above the window.

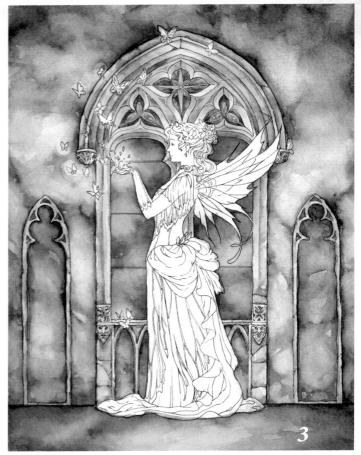

2 Add Stone Texture and Window Color

Paint a light layer of Quinacridone Violet over the main part of the window. Then paint a second layer of color around the edges and the figure, blending out with clear water to make it look cloudy. Paint the two trefoil windows on each side with light Quinacridone Red, then Quinacridone Violet over the outer edges.

Apply a mix of Cadmium Yellow and Cadmium Orange to the star center in the top window. Use Quinacridone Violet and Dioxazine Purple around the star, blending the color toward the outer edges. Around all the windows, allow a dilution of the color to bleed out over the stonework.

Glaze reflected light over the ground around the figure with light Quinacridone Violet. Add some midtones to the stone arches and corners with Payne's Gray mixed with varying amounts of Ultramarine Violet Deep.

3 Intensify the Window and Deepen the Stone

Darken the sky through the main window with Quinacridone Violet.

Create the irregular glass texture on the two trefoil windows with Quinacridone Violet on the outer edges and Quinacridone Red and Alizarin Crimson in the center. Darken the outer sections with a little Dioxazine Purple.

Glaze the center window with light Quinacridone Red from the outer edges. Darken the center star with Quinacridone Red plus Alizarin Crimson, then Cadmium Orange and Yellow in the center.

Glaze the stone surrounding the upper windows and arch from the sides to the center with Quinacridone Red, Dioxazine Purple and then Cadmium Orange.

Shade the background with Payne's Gray, adding in some Dioxazine Purple in the lighter areas. Darken the color around the arches, corners and where the wall meets the ground. Leave a light halo around the butterflies. Paint dark spots here and there around the window and arches, blending out the color into the surrounding areas. Make the stone look uneven and broken by painting in irregular shapes.

Paint very light Payne's Gray at the inner corners of the upper windows and blend downward.

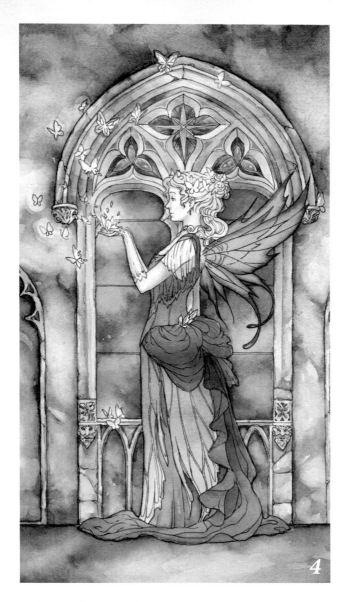

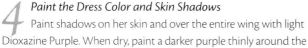

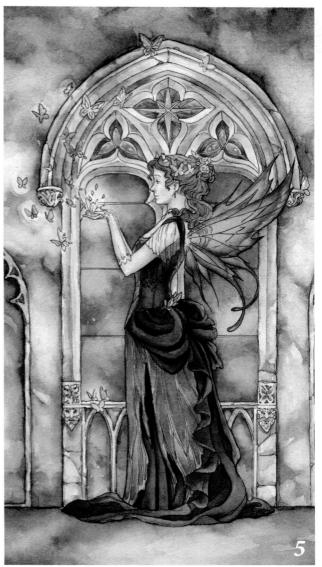

4 *Paint the Dress Color and Skin Shadows*
Paint shadows on her skin and over the entire wing with light Dioxazine Purple. When dry, paint a darker purple thinly around the edges, blending the color inward.

Paint purple over her bodice, underskirt and bustle. Glaze Cobalt Blue over the bodice when dry. Use light Quinacridone Red to paint the wing-shaped skirts. When dry, glaze purple at the top and blend toward the bottom. While still wet, drop in a little Cobalt Blue.

5 *Darken the Figure and Paint the Butterflies*
Glaze Raw Sienna over her skin. Then glaze light Quinacridone Violet darkest toward the bottom of the wing and skirt and blend up. When dry, fill in the bottom individual wing sections with darker Quinacridone Violet and blend up. Then do the same with Dioxazine Purple, starting from the top.

Shade the rest of the purple parts of the dress, bodice, skirt and bustle with Dioxazine Purple. Mix Dioxazine Purple and Payne's Gray to create the darkest shadows.

Paint a line of Quinacridone Violet along the outer edge of the wings and blend so it fades inward.

Paint the base colors on the butterflies with Dioxazine Purple, Cadmium Red, Cadmium Yellow, Cadmium Orange and Cobalt and Cerulean Blue.

Paint her hair with a mix of Burnt Sienna and Raw Umber.

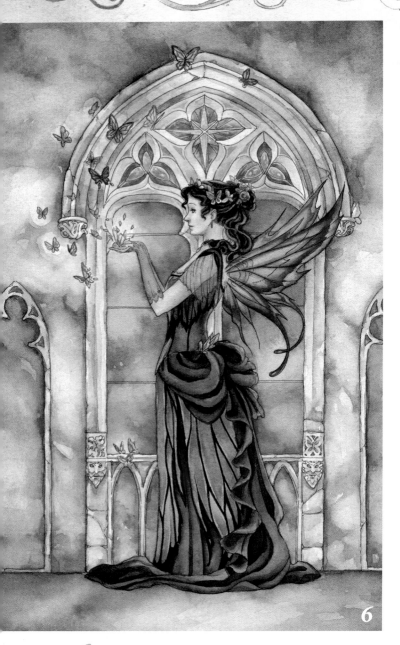

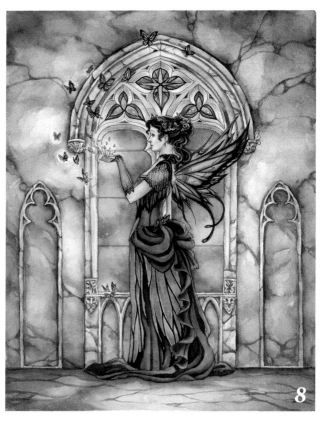

6 Finish the Skin and Add Dress Details
Glaze Brown Madder over the darker shadows on her skin, adding a little Quinacridone Red on the cheeks and Alizarin Crimson on the lips. Outline the eyes with Raw Umber and Sepia. Darken her hair with Sepia and pick out some of the strands using Lamp Black. Use Dioxazine Purple and Hooker's Green for the roses in her hair.

Paint details on the butterflies with various colors. Paint wing veins and outline with slightly darker colors.

Glaze a line of Dioxazine Purple over the red stripe on her wings and blend inward.

Outline the wings with Lamp Black. Outline both the vein pattern on her skirts and the lacy trim on her bodice. Paint her transparent lace glove and sleeve with very diluted black. Then glaze the trailing end of her bustle and deeper folds with a diluted black.

7 Add Wing Details
Finish details on the wings with Lamp Black. Outline the outer edges and paint a lacy pattern. Trace the veins, then outline the lace on her sleeve and glove, creating a lace trim with scallops, loops and dots. Outline and detail the butterflies.

8 Add Cracks in the Stone
Glaze Payne's Gray around the outer edges of the picture. Paint the cracks in the stone. Place where some of the stone is darker and already looks broken.
Fill in and trace the leading on the stained-glass panels.

9 Add Highlights
Use White Gouache to add highlights and reflections to some of the cracks. Dot small spots on the wings and butterflies. Finally, fill in the leading on the large window with Payne's Gray.

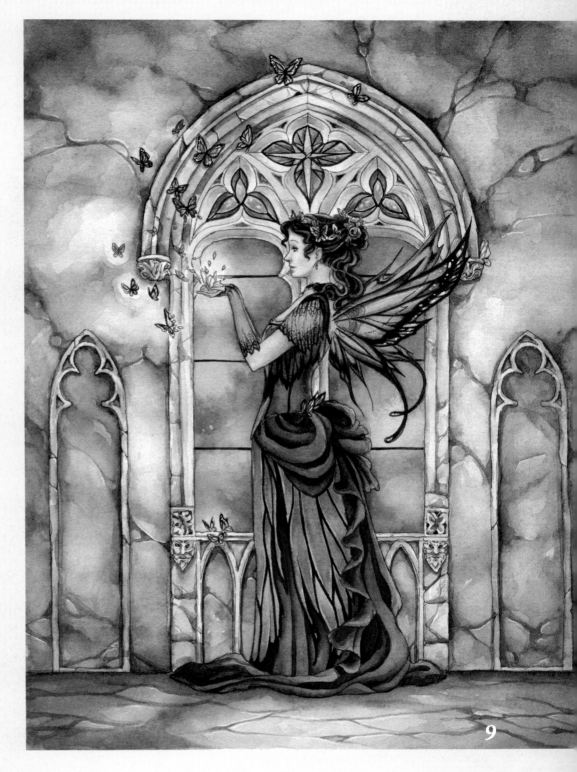

Steampunk

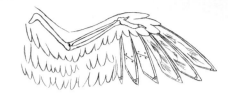

STEAMPUNK IS A FANTASTICAL COMBINATION of history and futurism. Imagine someone from the nineteenth century describing what one hundred years in the future would look like to them with a good helping of fantasy. While steampunk is most often based on Victorian styles, you can branch out to include other regions of the world. Use design motifs from a historical period in your futuristic items.

Choose mechanical elements that make sense and look functional, such as jet packs, wings that move, mechanical limbs and spyglasses, rather than adding gears as an afterthought. Deconstruct costume items and use corsets and bustles on the outside.

Study the Skeletal Form
Reference the bone structure of bird wings to create a deconstructed mechanical wing. Create a skeleton of metal and wood, adding glass or metal feathers, or stretch fabric over it like a ship's sail.

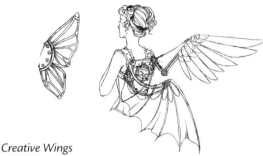

Creative Wings
Draw a small butterfly-style wing made from metal and glass that catches the light. Bird-like wings can be constructed with joints to open and close. Wings might be attached to a pack containing the mechanisms that make them work.

Steampunk Details
Military-style double-breasted jackets and vests look appropriate for a steampunk costume, giving an air of authority to your character. Spats are Victorian shoe and boot covers that keep shoes free from mud. They cover the ankle and top of the shoe with buttons up the side. Experiment with drawing them knee- or thigh-high, or decorating them with trims.

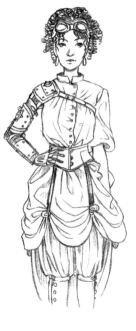

Character Study 1
She wears a mechanical arm attached with a belt and a short waist cincher, which still allows for plenty of movement. Skirt lifters are used to draw up a long skirt and keep it out of the way. Under that, she wears knee-length bloomers.

Bloomers allowed for activities such as biking and were controversial in Victorian England, when women did not yet wear pants.

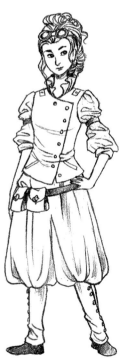

Character Study 2
This character is dressed with utility in mind. The multiple pockets on her belt carry supplies for adventuring. Goggles protect her eyes in flight, and spats protect her boots and keep her legs warm. Bands around her arms keep her sleeves rolled up.

Ideas to Incorporate

Corsets	Utility belts
Goggles	Top hats
Bustles	Military jackets
Bloomers	Spats
Hoop skirts	Safari gear
Leather holsters	Skirt lifters
Jet packs	

Leather and Brass

STEAMPUNK COSTUMES frequently make use of leather and brass details. Both are materials that can be elegant and utilitarian, shiny or worn.

MATERIALS

assorted brushes

hot-pressed watercolor
 paper

PAINTS

Burnt Sienna

Raw Umber

Sepia

White Gouache

Yellow Ochre

Leather

1 Paint the Base Color
Paint a flat wash of Burnt Sienna.

2 Drybrush the Texture
Mix Burnt Sienna with Sepia and use a no. 4 brush to drybrush texture over the left side. Build up a couple of layers on top of each other and then drybrush with pure Burnt Sienna. Use a no. 2 brush to mimic a tooled leather design. Paint the inner edges of the gear outline and blend toward the center. Drybrush more Burnt Sienna around the right corner, leaving a thin line at the edge of the gear.

3 Create Highlights
Lift out highlights around the outer edges of the gear with a clean wet brush. Add extra highlights with White Gouache.

Tarnished Brass

1 Paint the Base Color
Paint a flat wash of light Yellow Ochre. Paint more concentrated color around the edges and blend inward.

2 Drybrush the Edge
Mix Yellow Ochre and Raw Umber, and build up layers of color around the edges using the drybrush technique.

3 Build up Medium Tones
Drybrush several layers of pure Yellow Ochre around the center and over the edges, but leave a bright area in the center. Then drybrush a little Raw Umber over the outer edges. You may use a smaller brush like no. 000 and any mix of colors to add scratches or dents for a worn appearance.

THE LOOKOUT

*A*TOP HER HIGH PERCH, an airship mechanic looks over the city with her brass spyglass and waits for her ship to come in. The Art Nouveau border and wrought-iron swirls bring to mind nineteenth-century architectural details while the sepia-toned background recalls antique photographs.

MATERIALS

assorted brushes

hot-pressed watercolor paper

pen, pencil and water-proof ink

PAINTS

Brown Madder

Burnt Sienna

Burnt Umber

Cadmium Red

Cadmium Yellow

Cerulean Blue

Cobalt Blue

Dioxazine Purple

Lamp Black

Payne's Gray

Raw Sienna

Raw Umber

Sepia

Viridian

White Gouache

Yellow Ochre

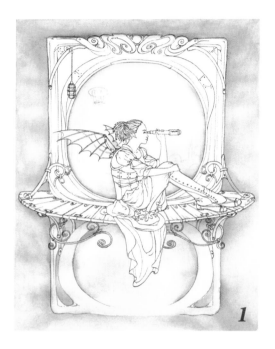

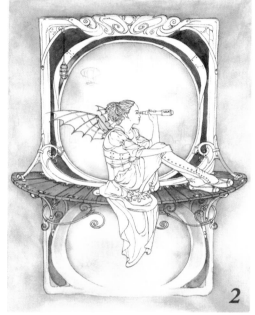

1 Begin the Background
Paint light Raw Umber unevenly over the background, around the frame and under the ledge. Smooth out darker spots with clean water. Paint around the edge of the center window and blend inward a little at a time, avoiding the frame and the figure.

2 Paint the Ledge and Frame
Paint a cloudy sky with light Cerulean Blue in the window. Paint some uneven areas around the window edge, blending out the color into the outline of clouds.

Paint the wooden ledge with Burnt Sienna, avoiding the metal studs. Paint Raw Umber in the dark depressions in the frame. Then paint shadows under the ledge, blending toward the bottom and filling in the lower frame.

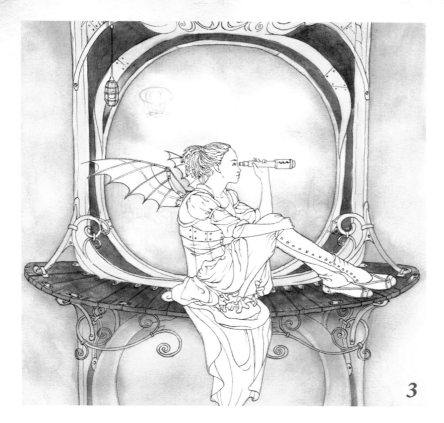

3

3 *Deepen the Sky*

Deepen the blue sky toward the edges and over the darkest parts using Cerulean Blue.

Paint Raw Umber over the wooden ledge, darkest toward the center around the figure. Paint light Yellow Ochre over the remaining parts of the frame, spyglass and metal parts of her wings and shoes.

4 *Add Details and Shading*

Lightly paint the skyline at the bottom of the window with light Raw Umber. Paint from the top edges down, making the bottom cloudy.

Outline the airship in the sky, with Raw Umber thinned out, and while wet, blend the color inward. Then paint her wings, darker at the base, and shade the spats on her lower legs and blouse with light Raw Umber.

Glaze the wood ledge with Sepia for shadows at the back edge and directly under the figure. Then paint the wood grain and areas between the boards.

Glaze Yellow Ochre over the gold frame at the top and bottom. Mix Burnt Sienna and Yellow Ochre to glaze over the shadows on the bottom. Begin painting medium values on the top frame. Paint the darkest spots first and blend the color out into a gradient. Reserve plenty of unpainted spots for highlights. Glaze Yellow Ochre over the dark brown areas and darken the metal on her wings and shoes.

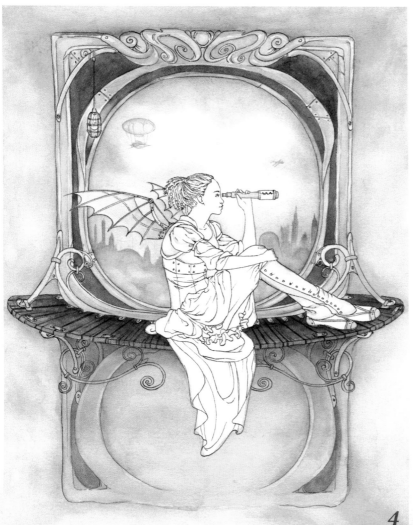

4

5 Paint Ironwork Swirls

Mix Burnt Sienna, Sepia and Yellow Ochre to paint deeper shadows on the gold frame. Paint Payne's Gray on the wrought-iron swirls and lamp. Glaze a little Cadmium Yellow around the lightbulb.

Paint shadows under the ironwork with Burnt Sienna, Sepia and Yellow Ochre. Use Sepia to deepen the color on the dark brown border top and bottom, and to darken the shadows under the ledge.

Add windows and rooftops on the skyline using Burnt Umber. Then add details to the airship in the background.

6 Paint Her Clothes and Skin

Paint a thin line of Burnt Umber around the inner edges of the lower circle. Glaze Cobalt Blue over the shadows on her blouse and spats. Begin painting shadows on her skin using Dioxazine Purple.

Paint her leather shoes, harness and the wood part of her wings with Burnt Sienna mixed with Raw Umber. Paint most of her clothing and the outside of her skirt with Cerulean Blue. Use light Viridian to paint the lining of her skirt and the design on her shoes. Paint the remaining section of the spyglass with Payne's Gray.

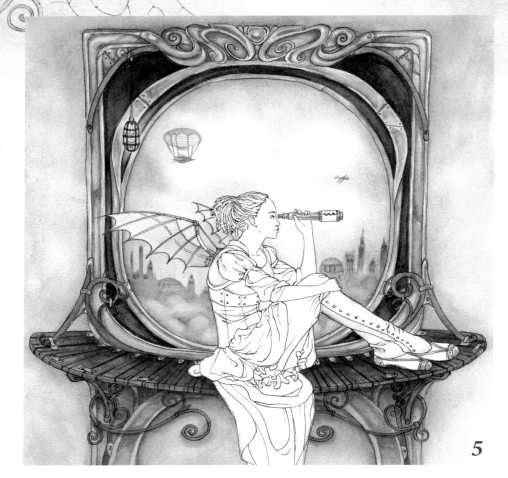

5

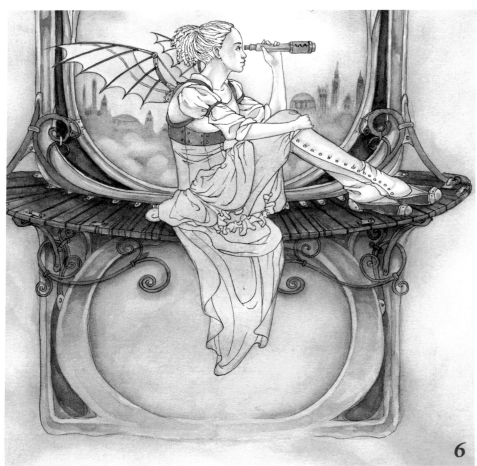

6

7 Add Midtones

Mix Raw Umber and Burnt Sienna to paint lightly over her skin. Use the mix in concentrated form to paint her hair and shade the leather harness.

Add shadows on her clothes and the green part of her shoes with Cobalt Blue. Lightly shade her skirt lining with Cerulean Blue.

Glaze Payne's Gray over the shadows on her spats and blouse. Use darker Payne's Gray to fill in the spats' buttons.

8 Deepen the Shadows on the Clothing

Paint Raw Umber plus Cadmium Red over shadows on her skin. Mix in a touch of Cobalt Blue for the darkest shadows. Glaze very pale Cadmium Red over her cheeks, chin and the tip of her nose.

Mix Cobalt Blue, Dioxazine Purple and a little Payne's Gray to paint the shadows on her outer skirt, bloomers and bodice. Then darken the blue on her shoes. Shade the leather parts with Sepia.

Paint shadows in the wrinkles in her skirt lining with Cobalt Blue, then darken them. Paint the brass trim on her shoes, wings and spyglass with Burnt Sienna and Yellow Ochre.

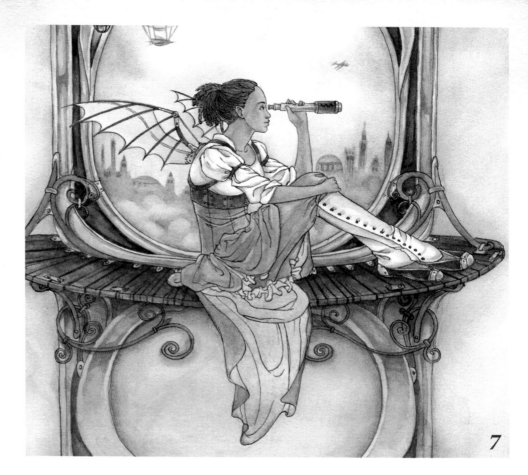

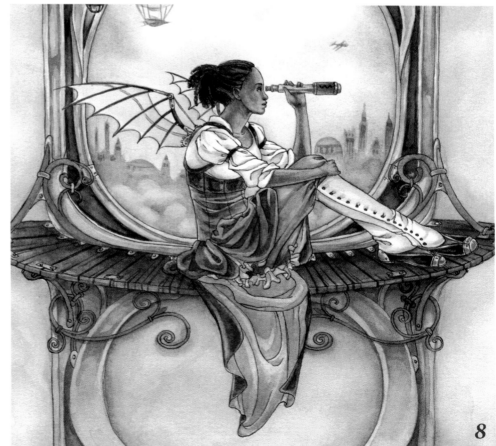

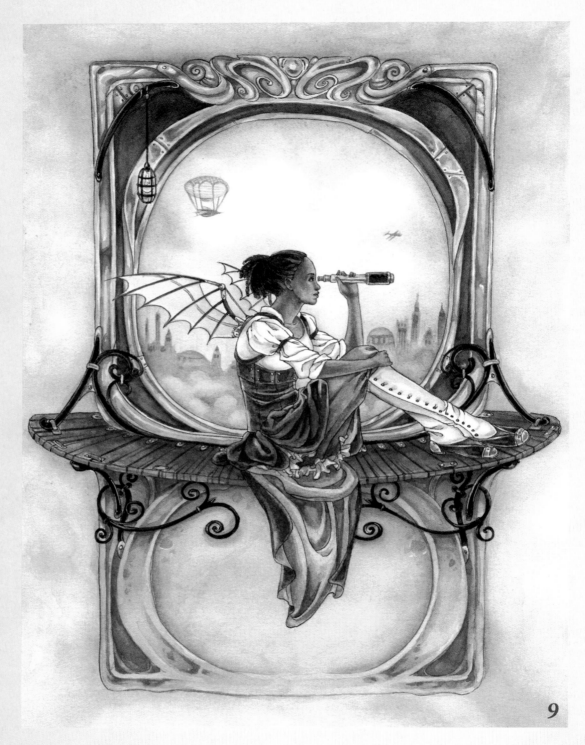

9

Finalize the Details

Build up the skin tones with Brown Madder over the shadows, cheek and lips. When dry, glaze Raw Sienna over all her skin. Use Lamp Black to add shadows in her hair.

Paint dark blue shadows on her skirt lining with the Cobalt Blue, Dioxazine Purple and Payne's Gray mixture. Deepen the shadows in the wrinkles on the rest of her skirt with Payne's Gray. Lightly glaze Dioxazine Purple over her torso and bloomers.

Add more shadows to the gold frame with Burnt Sienna plus Raw Umber, especially between the swirls at the top. Add some small pockmarks on the bottom frame for a rougher texture.

Fill in the ironwork with more Payne's Gray. Then use White Gouache to create highlights on buttons, gold and wrought iron.

Index

quote brief passages in a review. Published by IMPACT Books, an imprint of F+W Media, Inc., 10151 Carver Road, Suite 200, Cincinnati, OH 45242. (800) 289-0963. First Edition.

Other fine IMPACT Books are available from your favorite bookstore, art supply store or online supplier. Visit our website at fwmedia.com.

17 16 15 14 13 5 4 3 2 1

ISBN: 978-1-4403-2831-2

Distributed in Canada by Fraser Direct
100 Armstrong Avenue
Georgetown, ON, Canada L7G 5S4
Tel: (905) 877-4411

Distributed in the U.K. and Europe
by F&W Media International, LTD
Brunel House, Forde Close, Newton Abbot, TQ12 4PU, UK
Tel: (+44) 1626 323200, Fax: (+44) 1626 323319
Email: enquiries@fwmedia.com

Distributed in Australia by Capricorn Link
P.O. Box 704, S. Windsor NSW, 2756 Australia
Tel: 02 4560 1600 Fax: 02 4577 5288
Email: books@capricornlink.com.au

Edited by Vanessa Wieland and Kristy Conlin
Designed by Clare Finney
Production coordinated by Mark Griffin

Metric Conversion Chart

To convert	to	multiply by
Inches	Centimeters	2.54
Centimeters	Inches	0.4
Feet	Centimeters	30.5
Centimeters	Feet	0.03
Yards	Meters	0.9
Meters	Yards	1.1
Meters	Yards	1.1

ABOUT THE AUTHOR

Meredith Dillman remembers filling pages and pages with tiny fairies and unicorns as a child, with a story behind each one. As a teenager she became fascinated by anime, manga and medieval-themed Pre-Raphaelite paintings.

Meredith studied art and illustration at Minnesota State University Moorhead, practicing watercolors and exploring her love of the fine lines of Art Nouveau, Japanese woodblock prints, and Golden Age Illustration. The intricate details she was drawn to in art history continue to inspire her paintings and designs.

Since she graduated in 2002 she has created a growing collection of fantasy and mythology-based personal work, and her art has been published in several instructional books as well as licensed for fantasy products and collectables. She authored and illustrated *Watercolor Made Easy: Fairies and Fantasy*, a fantasy watercolor technique painting guide. This is her second book.

Visit her website at www.meredithdillman.com

DEDICATIONS & ACKNOWLEDGMENTS

Thank you to Ray for all of your patience and help with photography and image editing. Thank you to friends and family for helpful advice and critiques.

Thanks to Pam Wissman for giving me the opportunity and Stephanie and Angela for encouraging me.

Ideas. Instruction. Inspiration.

Download FREE demonstrations and instruction
at impact-books.com/fantasy-fashion.

These and other fine IMPACT
products are available at your local
art & craft retailer, bookstore or
online supplier. Visit our website at
www.impact-books.com.

Follow IMPACT for the latest
news, free wallpapers, free
demos and chances to win
FREE BOOKS!

impact-books.com

- Connect with your favorite artists
- Get the latest in comic, fantasy and sci-fi
 art instruction, tips and techniques
- Be the first to get special deals on the
 products you need to improve your art